WATER COLOR

for beginners

A fun and comprehensive guide to watercolor
painting using a simple set of supplies

Emma Witte

Peter Pauper Press Inc.
WHITE PLAINS, NEW YORK

Our Company

In 1928, at the age of twenty-two, Peter Beilenson began printing books on a small press in the basement of his parents' home in Larchmont, New York. Peter—and later, his wife, Edna—sought to create fine books that sold at "prices even a pauper could afford."

Today, still family owned and operated, Peter Pauper Press continues to honor our founders' legacy—and our customers' expectations—of beauty, quality, and value.

———

Published by Peter Pauper Press, Inc.
202 Mamaroneck Avenue
White Plains, New York 10601 USA

Published in the United Kingdom and Europe by Peter Pauper Press Inc.
c/o White Pebble International
Unit 2, Plot 11 Terminus Rd.
Chichester, West Sussex PO19 8TX, UK

Library of Congress Cataloging-in-Publication Data available.

ISBN 978-1-4413-3465-7
Manufactured for Peter Pauper Press, Inc.
Printed in China

7 6 5 4 3 2 1

Visit us at www.peterpauper.com

WATER
COLOR
for beginners

A fun and comprehensive guide to watercolor
painting using a simple set of supplies

Table of contents

LEARN THE RULES LIKE A *pro* SO YOU CAN BREAK THEM LIKE AN *artist*

— UNKNOWN

introduction

Hey there, paint pal! Welcome to my world of watercolor.

One of my favorite things about art is riding the waves that ebb and flow between the rigid rules of an artistic medium and the freedom to create whatever you want once you've learned them. I love the satisfaction of being able to let loose and create something totally unique, guided by foundational skills so you don't feel overwhelmed by the blank page. This is exactly what attracted me to watercolor.

But . . . I found it extremely challenging to learn! Although as an art form, watercolor has been around and taught for a long time, it still can be wild and unpredictable, and there are so many supplies, brands, techniques, and places to learn out there. It's really hard to know where to start.

Perhaps that's why you picked up this book. Maybe you're finding it challenging too, or you're feeling overwhelmed with options. It can be discouraging to see endless seemingly simple paintings online, only to pick up your brush and create a muddy mess. Trust me, I've created a lot of those!

What allowed me to finally get the hang of watercolor was to pare back everything I needed, and work with just the basics. Only a couple of colors. One shape of brush. One type of paper. I still paint like that to this day! The simplicity and minimal structure enable me to feel like I have some control over what can be a very uncontrollable medium. It reduces the number of decisions I need to make, meaning I can direct that energy towards mastering techniques and creating something new and different every time I sit down to paint.

Many people say watercolor is one of the hardest mediums to learn, but I reckon it's the way we learn something that dictates whether it's hard or not. I hope my minimal supplies and focus on color theory and technique when learning watercolor, along with gradually increasing the complexity of each project in this book, help you get the results you're looking for faster and fill you with confidence to create.

Let's get started!

materials

Let me level with you, paint pal. There's an overwhelming number of brands and options out there when it comes to watercolor supplies. Overwhelming.

I like to keep my toolkit simple, and in order to do that I'm going to recommend my preferred supplies and brands. But these are not your only options. If you can't find them locally, you don't have the cash for them just yet, or you just don't want to use these specific supplies, that's fine. Please do not feel pressured to buy the exact things I recommend. They are just what works best for me, and can be a starting point for you if you have no idea where to begin. But by no means are they the best, nor do you need these exact supplies to learn or get good at watercolor.

In the following pages, I'll go over why I've chosen the few supplies that I have in my toolkit, to empower you with the knowledge of what makes watercolor supplies different and why it's important. This will help you feel more confident when choosing supplies or expanding your kit in the future.

My favorite everyday supplies

Paper: Arches Cold Pressed Watercolor Paper, 90lb

Brushes: Princeton Heritage round in three sizes: 3/0, 6, and 8

Primary colors: Winsor and Newton Professional Series watercolors in Winsor Lemon, Permanent Rose, and Winsor Blue (Red Shade)

Convenience white: Winsor and Newton Designer's Gouache in Permanent White

Convenience black: Winsor and Newton Professional Series Watercolor in Mars Black

Palette: K-mart dinner plates are cheap and provide plenty of mixing space. Any plastic or ceramic palette is fine.

Glass water jars (x 2): One for cool colors, one for warm colors; glass, as it's harder to tip over by accident

Paper towels: For water control, mistakes, and techniques

Painter's tape: To secure painting to surface and prevent warping

Pencil

Eraser

EXTRAS THAT I LOVE BUT THAT AREN'T CRITICAL:

Light pad: For tracing outlines (I use an A3 Huion.)

Heat gun: To dry paintings faster (I use an embossing heat tool.)

Washi tape: For creating color charts or abstract patterns

Note: I paint with my handmade watercolors from my brand The Watercolour Factory, but I have given you my commercial recommendation of Winsor and Newton, which is what I used before I made my own. The great thing about Winsor and Newton (besides their quality) is that they're readily available in most places. If you want to paint with the exact pigments I use, look for pigment numbers PY74, PR122, and PB15:3 (see page 23) from a brand of your choice (usually listed on the back of the tube or pan label).

Ready for a deep-dive into the wonderful world of watercolor supplies? If this feels like information overload, come back to it another time. I want to help you understand just why watercolor can be the most difficult medium to learn, and make it more approachable by explaining all the intricacies of each supply to you . . . but I also don't want your brain to ache.

BUT FIRST: STUDENT VS. ARTIST-GRADE

If you've ever been to an art store, you've probably browsed the shelves and wondered why there are such discrepancies between the prices of art supplies.

- **Why are some paints and brushes more expensive than others?**
- **Does the higher price tag mean higher quality?**
- **How do I buy what I need to succeed with watercolor without having to remortgage the house, sell a kidney, and take out a small loan?**

Well, sometimes a higher price tag can mean better quality, but not always. Generally speaking, there are two main levels of watercolor supplies—student and artist (or professional) grade.

Student grade supplies are aimed at, you guessed it, students. With many art

forms, you can start off with student (beginner) grade and progress up to artist/ professional supplies once you've gained more experience and saved up for it. But with watercolor, we often find that this leads to wasted time and supplies, and a ton of frustration.

With watercolor, you really do get superior results with superior supplies, and upgrading from student to artist/professional grade involves a huge learning curve. The defining feature of watercolor is—you guessed it—water, and as you learn you begin to get used to **water ratios**: how much to use and how to apply it. When you upgrade from student to artist-grade, you need to re-learn all of that. That's because better paints have more pigment in them, better brushes hold more water, and better paper absorbs differently.

If this is not a concern for you, and you're happy to start with lower-grade supplies and figure all that stuff out on your own, that's fine. Everyone is different and some people don't mind the longer route. Some even enjoy the scenery.

But if you're an impatient learner like me, I'll explain the differences for you in the following sections, as well as give you some tips to save money but still get the good stuff without running up a huge bill at the art store. I do believe it's worth it in the long run, even if it's just saving you frustration.

Paper

If there's one important supply in watercolor, it's paper. Paper can be the difference between having a great time with watercolor, and wanting to throw in the (paper) towel. I've seen many, many beginners become frustrated with learning watercolor because they think their skills are holding them back, when really it's their supplies, most often their paper. I know the cost of paper can be off-putting, and please don't think you need to remortgage your house just to take up a new hobby, but consider trying better paper if you're not getting the results you want.

To paint with watercolor we need to use watercolor paper that has been "sized." This means it has had a solution (often gelatin) added to it either during or after production, usually both internally and externally with high quality brands, to make it withstand water. Think of printer paper. If we wet it, it just gets all soggy and floppy. Watercolor paper can be painted on without water soaking through to the other side.

TEXTURE

The first thing we need to consider when choosing watercolor paper is the texture. Your choice of texture could be based on personal preference, the type of paintings you prefer to create, and your budget.

> **Hot pressed:** Tightly compressed paper fibers, smooth texture, less surface area. Best suited to detail work. Doesn't handle excess water well, and it can run in places you didn't intend, as there isn't much for the water to "grip" onto.

> **Cold pressed:** Middle ground between hot pressed and rough. Most commonly-used paper. Sometimes referred to as "not" watercolor paper, as in "not hot pressed." Can handle water well and provides a moderate amount of texture.

Rough: Loosely compressed paper fibers, rough texture, large surface area. Best suited to work involving a lot of water, or the desire to include a lot of texture.

WEIGHT

The next thing to consider is the weight of the paper. This essentially means how thin or thick the paper is. The thinner the paper is, the more likely it will buckle and warp when water is applied, and the thicker the paper, the more resistant it is to buckling. However, the thicker the paper, the higher the price tag. There are lots of ways to prevent warping, and I personally don't mind buying a thinner paper to save the cash, especially if I'm just painting for myself. I use 90 lb most of the time.

Weight is usually mentioned in gsm and lb on the cover or package of the paper. Some common weights in order of lightest to heaviest and cheapest to most expensive are 90 lb (190 gsm), 140 lb (300 gsm), and 300 lb (600 gsm).

FORMAT

Paper format is another way in which you can save money. We pay for convenience, after all.

Block: A block of watercolor paper is the most expensive format, but it's also the easiest way to prevent your paper from warping. Blocks of paper have their sides glued down tightly at the edges, with a small gap for you to insert a ruler or similar into. The paper cannot warp when wet because it's stretched and glued so tight around the edges, and once it dries, you can slide a ruler or palette knife into the gap in the glue to separate it from the rest of the pages. Note: Some blocks only have two sides glued down, and still warp.

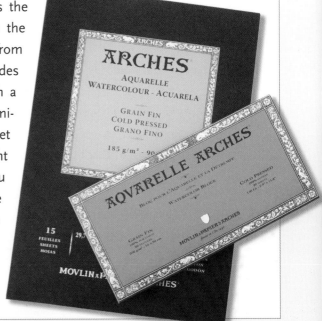

Pad: A popular option is a pad of watercolor paper, with the top side glued down. This is my personal preference due to ease of storage, use, and cost. I tear the paper from the pad before use, and tape it down to minimize warping.

Loose sheet: You can also buy unbound sheets. These can be pretty cost effective, and usually come in large sizes. They tend to have deckled edges and the brand logo debossed on one corner.

Roll: The most economical format of paper is generally a roll. However, it is the most expensive upfront, and you'll have to cut it up into the size you want, as well as store the large roll. I wouldn't recommend starting with a roll of paper, but you may choose to get your paper that way in future if you find yourself painting a lot.

SIZE

There are plenty of sizes to choose from, often depending on the brand you prefer. I usually buy my pads of paper in A3 size, but I prefer to paint in A4 and A5, so I cut them down myself. This tends to save a little bit of money. You can save more by grabbing large loose sheets or of course a roll, but you'll have to cut it down. It may be more convenient for you to buy a smaller size. One of many things to consider!

COLOR

Watercolor paper doesn't come in a wide range of colors, but there are often different shades of white to choose from, from natural to bright white. The only time I would really give this much thought is if I were painting something for a client, or wanting to scan a painting onto my computer without spending forever trying to edit out an off-white background. Black watercolor paper has also become popular lately, mostly with artists who like to paint with gouache or metallic watercolors.

MATERIALS

The last thing to consider when it comes to watercolor paper is what it's made out of. At the end of the day it doesn't really matter what format, weight, size, or color you buy your paper in. Those things aren't critical to the outcome of your paintings. But the materials that make up your paper are. This goes back to the student vs. artist-grade issue I raised earlier this chapter. Here is my summary of paper types:

Student: Generally made from wood pulp, sometimes mixed with cotton. Colors can appear less vibrant, water absorption not as good as artist-grade, can create harsh lines and be incapable of taking multiple layers of paint.

Artist: Generally acid-free, archival, and 100% cotton or "rag." Holds water well, harsh lines reduced, colors are more vibrant, multiple layers can be added without pilling. Does not yellow over time or after extended exposure to sunlight.

Often with watercolor supplies, you get what you pay for. I recommend 100% cotton and acid-free paper for the best painting experience. If you get to a point of being so frustrated with watercolor that you want to give up, and you're using a cheaper type of paper, please consider upgrading. It is more often than not the reason for beginners' frustration.

Recommendation: Arches Cold Pressed or Fabriano Artistico Cold Pressed paper

TIPS FOR SAVING ON PAPER

- Buy in formats other than a block, and tape it down to avoid buckling.
- Buy in larger sizes and cut it down.
- Buy in a lighter weight (gsm/lb).
- Paint on both sides. (Not all brands and qualities will allow this, but you can still practice on the back, even if it doesn't look as "nice" as the front.)

TIPS FOR CARING FOR YOUR PAPER

- When not in use, store out of direct sunlight—flat if possible and away from sources of moisture. (Archival storage files and boxes are available to buy if you are so inclined.)

- Try not to handle the painting surface excessively with your fingers, as you can transfer oils to the paper that can affect the absorption of water and paint.

- When framing a finished piece, put it behind glass and use 100% acid-free matting and backing to keep the paper off the glass surface (where moisture can sometimes present itself) and to ensure no harmful acids touch the paper.

STRETCHING WATERCOLOR PAPER

Whoa, put down the gym equipment. You don't need muscles for this! Stretching watercolor paper is something you can do if you want to prevent it from warping. I almost never do this because it's an extra step that I'm way too lazy for, and there are other alternatives that I prefer. (Some examples are taping down paper, using blocks of paper, and even ironing paper. More on that next.) But many artists, particularly commission and gallery artists who sell their originals, will do this.

Stretching watercolor paper essentially involves getting the paper as wet as it can possibly get, securing it tightly, and forcing it to dry taut and "stretch." When you paint your actual painting on it, it has already withstood more than that amount of water, so it won't buckle.

You'll need:

- Your paper

- A tub or container to submerge your paper in (You can also use a sponge to wet it down. Be careful not to scrub the surface of the paper, though.)

- A rigid board larger than your paper

- Gummed tape or a stapler

- More patience than me

Instructions:

- Soak the piece of paper in a container of water for 5 to 10 minutes until it feels like a floppy rag.
- Carefully transport it to your board and lay it down. Start by placing the curved middle on the board. Then lay the sides down to avoid air bubbles getting trapped underneath.
- Use a sponge to wet the gummed tape on both sides and then apply it to each edge of the paper, half on paper and half on board. Try not to let the tape drip on the paper, as it can leave marks. If using a stapler instead, staple around the perimeter of the paper, securing it to the board.
- Leave to air dry completely for 24 to 48 hours.
- Then, paint away!

Once your painting is dry, use a craft knife to cut your paper off the board. You can't peel gummed tape off, and cutting can be easier than trying to remove staples without ripping.

HOW TO FIX YOUR WARPED PAPER WHEN YOU'RE IMPATIENT AND LAZY LIKE ME

So you WARPED your paper. Welcome to the club; I'm president. If you've somehow managed to buckle your paper and you desperately need it to be flat, all is not lost. I used to sit my bent paintings under heavy books for a couple of days, but I've found a way to flatten it better and faster. (Books are still helpful.)

You'll need:

- Your warped painting

- An iron

- Brush and clean water

- A couple of towels

- Heavy books

Instructions:

- Put down a towel and lay your painting face down onto it.

- Wet the back of your painting using a brush (or a spray bottle of water if you want). Be careful not to splash water all over the place, causing it to get on the front of the painting.

- Put another towel on top of the wet paper. We don't want to directly iron the painting.

- With your painting facedown, the back of it damp and sandwiched between two towels, iron over the top towel. How long you need to do this will depend on how intense the warping was. Check on it every now and then to see if it has dried out and flattened.

- Once the painting has dried and is flat, remove it from between the towels.

- Stack some heavy books on top, and come back for your flat painting the next day! I like to sandwich it between two pieces of plain printer paper just so the painting isn't directly touching my table or books.

Paint

When I first started learning watercolor, I took the advice of an artist I followed on social media and bought their recommended colors. About 20 of them. Professional quality. $300+. I honestly thought by just buying the exact supplies this person recommended, I would become as good as them. Of course, right?

Wrong.

Not only did I end up with a bunch of colors I barely used, I spent far too much up front. I didn't know what colors looked good together or how to mix without muddy results. I had a handful of favorites, and I just felt too overwhelmed every time I looked at my palette. I stopped wanting to even try.

This frustration led me to go all the way back to the beginning and learn color theory (page 48), and it's ultimately why I paint with a limited palette to this day. Sometimes a small amount of supplies can feel like a restriction, but to me it was freedom because it made me feel less overwhelmed.

I wanted to paint with (and encourage others to paint with) professional quality paint, without breaking the bank. That's another reason why the allure of color theory and using a limited palette was so strong! If you have a choice between buying 12 student-grade paints or 3 artist-grade paints, I encourage you to grab the artist-grade paints in primaries and learn to mix.

With the color issue out of the way for now, you can decide what format of watercolor to paint with.

FORMATS

Tube

Tube paint comes in, you guessed it, a tube. You can squeeze these colors out wherever you like, they come out moist, and you can close the tube and re-use the paint in it later. Sometimes decades later! These are generally formulated differently from pan (dried) watercolor. Because the paint is used fresh from the tube, it's usually easy to get very saturated colors, as you don't need as much water to activate them. However, most people don't need extremely saturated colors and find them too easy to waste. Instead, they squeeze tube paint out onto their palette and let it dry, then use it like pan colors. So why bother with tubes? They're flexible! You can use them fresh or dry, and place them wherever you want on your palette. Tubes generally come in several different sizes, too.

Pan

Pan watercolor usually comes in small plastic pans or half-pans. You can also buy palettes that allow you to clip these pans into them securely. I personally use pans these days, and I simply blu-tack the pans around the edge of my very fancy round dinner plate, then mix my colors in the middle. If I were to use tubes again, I'd do something similar and just squeeze my primary colors out on the edges of my plate. Pans can be a travel-friendly option as well, and can help you to better control the amount of saturation compared to tubes. One format is not better than the other. It really comes down to preference.

Liquid

Liquid watercolors are a really runny dye-based type of watercolor. I've listed them in the top three formats, as they're pretty popular, but I rarely recommend using them, especially not for the types of paintings I do and teach. They're very liquidy and often not lightfast (meaning they'll fade), they stain the paper in a way that's hard to manipulate, and they aren't reusable in their dry form like tube and pan watercolor. If you put liquid watercolors on a palette and let them dry, they'll flake off. However, if you really love bright and vibrant colors, go for it. One benefit is

that they usually come in a bottle with a dropper, so you can accurately dispense an exact amount of color, which can be useful for mixes.

Other: marker, pencil, crayon

You can also find watercolors in markers, pencils, and crayons, but I rarely find a use for them in my own work. You might, though! If you love mixed media or just applying color with more than a brush, check them out. Some brands have paints, markers, and crayons that all come in the same colors and all work with each other extremely well, so you could combine several formats into one piece. Without water, markers tend to stain the paper, and pencils and crayons will look "sketchy" before you add water if your paper is textured. If you're going to invest in any of these, consider a watercolor pencil, so that you can use it to sketch outlines and have it disappear when you paint (something that lead pencil doesn't do).

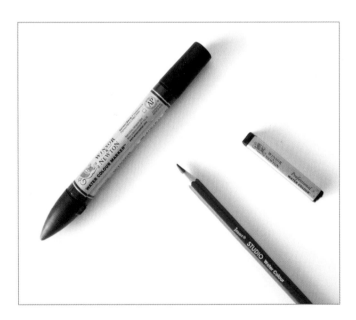

QUALITY

As you've probably gathered by now, I only paint with a few pigments. But from those few, we can make almost any others. (see the Color Theory chapter on page 42.) At the end of the day, I'm not fussed exactly which brand and which pigments from those brands you choose for your primary colors. However, now is a good time to bring up the student vs. artist-grade comparison.

- **Student:** Often made with cheaper ingredients. Contains more unnecessary "filler" to bulk up the paint, and less pigment. You use more paint and more layers. Can dry with hard lines, and less vibrant than artist-grade. Finish can appear chalky.

- **Artist:** Made with higher-quality ingredients. Has less "filler" and more pigment. A little goes a long way. More expensive up front but economical in the long run.

I do believe artist-grade watercolors make a huge difference, but there are plenty of student-grade options that are fine. The important part is to acknowledge the difference, and make your choices from there. If you don't mind doing a few extra layers or having slightly less vibrant results, then don't worry about going artist-grade yet!

UNDERSTANDING PACKAGING

Pigment numbers

Color names can be confusing. Please know that they are NOT consistent across manufacturers. A brand can call their colors whatever they want, and a "Winsor Lemon" simply will not exist in a Daniel Smith range, because it has been named after the brand Winsor and Newton. So rather than look for the same name across brands, it helps to look at the pigment numbers. A pigment number is an official code given by the Color Index International to identify colors. It will be something like "PB15." P for Pigment, B for the color family blue, and then an identifying number. You don't need to know these numbers by heart, but remember to double-check pigment numbers

when you want to buy the same color from a different brand, and search online for a pigment number if you want to find out more about it. There may be small differences in the same pigment across brands, depending on the manufacturing process for each brand. There are also some colors, such as Raw Sienna and Burnt Sienna, that originate from the same pigment. Burnt Sienna is roasted before being made into paint, giving it a different color from Raw Sienna.

Another reason I bring pigment numbers to your attention is that there are plenty of student-grade watercolors made with the same pigments as artist-grade paints, while some are not. When both types use the same pigment, there is more pigment in the artist-grade version. That's why you pay more for it—you're paying for pigment load. If you do use student-grade colors, choose primary colors that are made from only one pigment. The more pigments that go into a single color (the more pigment numbers on the packaging), the "dirtier" your mixes will be. Try to avoid primary colors with the word "hue" in them, as this generally means the manufacturer is using a substitute for the actual pigment.

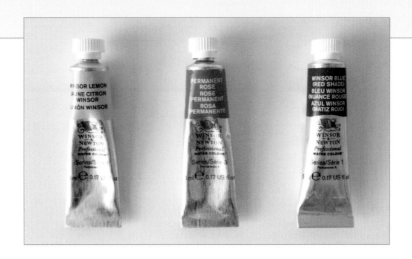

PRIMARY COLORS

If you have a preferred brand, try doing an internet search to find that brand's recommended primary colors. This means the brand has specifically chosen those colors for a limited palette from their range, and will give you a great range of colors. However, please be aware that some brands will not subscribe to the modern color wheel (page 48). Brands will often sell "primary sets" or "limited sets" based on the traditional color wheel, which will yield less vibrant mixes than primary sets with a more magenta-red or more turquoise-blue. I've done some of the work for you and chosen some popular commercial brands below, with my recommended primary colors from each.

Primary color recommendations:

Winsor and Newton: Winsor Lemon, Permanent Rose, Winsor Blue (red shade)

Daniel Smith: Hansa Yellow Medium, Quinacridone Rose, Phthalo Blue (green shade)

Sennelier: Primary Yellow, Rose Madder Lake, Phthalo Blue

The Watercolour Factory: Primary Yellow, Primary Red, Primary Blue

As with all of my recommendations, don't feel as though you must go with these, and explore student-grade colors if you are on a budget.

OTHER COLORS

As you may have noticed at the start of this chapter, I recommend a white and a black. This is often seen as a big no-no among very traditional artists. They instead believe you should mix your own black (more on that on page 58) and that you should preserve the white of your paper for white. As mentioned in the introduction to this book, learn the rules, then break them! I sometimes can't be bothered mixing black, or maybe I want a large amount of it and I want it to be perfectly uniform. I also can't be bothered using masking fluid, waiting for it to dry, then peeling it off to preserve the white of the paper. I'd much rather "cheat" and paint white over the top. If my way sounds good to you, consider grabbing these:

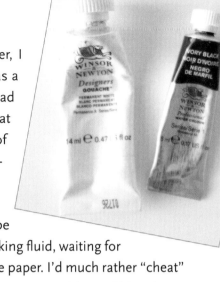

- **Convenience white:** I prefer white gouache over watercolor, as it's more opaque and better for layering over the top of an already painted area. Gouache can be used with watercolor, and is pretty similar, except it has chalk added, which makes it more opaque. My go-to is Winsor and Newton Designer's Gouache in Permanent White. However, for many years I also used Dr. Ph. Martin's Bleed-proof White, which is also excellent. Even with gouache, you sometimes have to paint several layers of white for high coverage.

- **Convenience black:** There are several pre-made black watercolors out there, but I always lean towards Mars Black, as it's a beautiful granulating color (more on that on the next page), meaning it dries with texture. I paint a lot of animals, and I love that texture on their fur or snouts. If you're not into that, consider a Lamp Black or Ivory Black. Beware: using too much pre-made black in a painting can flatten it, which is why many artists prefer to mix their own black, so that it has undertones of other colors.

CHARACTERISTICS OF WATERCOLORS

Pigment numbers are just one thing to pay attention to when selecting your watercolors. There are a bunch of other characteristics worth looking out for!

- **Lightfastness:** An official ASTM (American Standard Test Measure) rating from I–V given to colors to indicate how long they will withstand exposure to sunlight. The scale ranges from less than two years to over 100 years, so it's worth looking at.

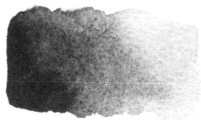

- **Granulation (above):** The pigment particles of this color are heavy and will settle in the valleys of your paper, creating a lovely cracked effect once dried. More noticeable the more water you use and the more textured the paper.

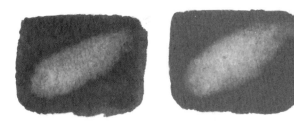

- **Staining (above):** Good to know if you really enjoy lifting colors off your page (see page 83), as a staining color cannot be completely lifted.
- **Coverage:** Usually defined as transparent, semi-transparent, semi-opaque, and opaque. Take this as a guide, as you can always dilute your colors.
- **Permanence:** Ability to withstand changes from light as well as atmosphere.
- **Series number:** Where relevant, lower series number in a brand indicates a lower price.

One reason I steer people towards artist-grade paints is that many student grade paints just don't carry this information. It can be very difficult to figure out what pigments went into them, how long they'll last before fading, and any unique ways in which they'll behave.

TIPS FOR SAVING ON PAINT:

- Mix from the primaries! If you learn to mix your own colors, you won't need as many and you can invest in artist-grade paints. (More on this in the Color Theory chapter on page 42.)

- Do not rinse leftover tube or pan paint down the sink. Watercolor can be reused, even if it's just a thin layer that has dried on your palette. (Note: Liquid watercolor doesn't keep in the same way.)

- Squeeze tube paint onto your palette or into wells, and let it set for 24 to 48 hours. By using it dry, you won't accidentally scoop a big glob onto your brush, and can better control the activation and saturation.

TIPS FOR CARING FOR PAINT:

- Always screw the lids back on your paint tubes after use, and before doing so, clean off any excess paint around the top of the tube and lid to prevent it from drying shut.

- If your paint lid has fused to the tube, run it under warm water. Watercolor is soluble, after all, so it should help free the lid. Clean thoroughly once you get it off.

- If you paint with an open palette, consider covering it with something when you're finished to prevent dust (or in my case, pet hair) from floating and drying on the paint. It's best to let it air-dry first, though, so you're not encouraging the growth of mold. I tend to gently place a piece of printer paper over my palette which prevents dust from landing in it, but it isn't sealed, so the paints still dry.

- If you've ended up with dust, pet hair, or even just other colors drying in your paints, you can clean them. I usually just get a damp brush, and gently scrub the surface, rinsing it off in water. Some people use sponges or paper towels to dab any unwanted dirt or paint off, or even give their palette a quick rinse in the sink.

Brushes

Brushes are undoubtedly an important tool in watercolor, but easily the one you can scrimp on the most! There are brushes that cost hundreds of dollars, and I personally don't think that's necessary. But again: It's all preference.

ANATOMY

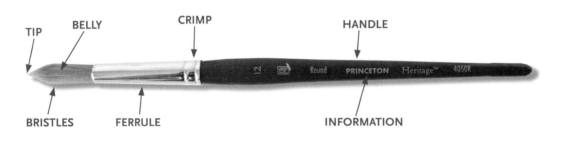

TIP BELLY CRIMP HANDLE

BRISTLES FERRULE INFORMATION

12 Round PRINCETON Heritage™ 4050R

SHAPES

Watercolor brushes come in many different shapes for many different reasons. Some of those reasons will be convenience, such as a flat wash brush being in a convenient shape to quickly cover large areas of your page with water. Some brush shapes are used to achieve specific brush strokes and textures.

I recommend that beginners start with round brushes. They're the most versatile shape, being able to achieve thin strokes using just the tip, as well as thick strokes that cover larger areas of the page by using the belly and holding the handle at a more horizontal angle. If you have the budget or the inclination, by all means grab some other shapes! My next recommendation would be a flat wash brush.

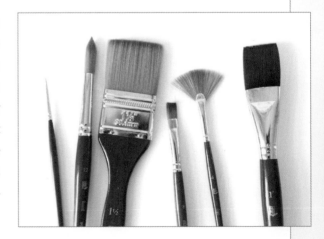

SIZES

In addition to the many shapes, brushes come in a ton of different sizes. But just like shapes, there's no need to rush out and buy the full set. My three most used brushes are 3/0 (tiny detail brush), size 6, and size 8, all in round. I find anything above 10 just feels massive to me, and I don't have much use for all of the smaller sizes between 3/0 and 6. It will totally depend on what you enjoy painting, though, and on the size you prefer to work at. If I wanted to paint only larger portraits, the small sizes I'm using would be too tedious. If you're looking for a starting point, though, try 3/0, 6, and 8. If you do want to buy a flat wash brush, a 1-inch (2.5 cm) brush would be a good place to start.

MATERIALS

The price and quality of brushes varies due to what they're made of and how. If you want traditional brushes made from the finest kolinsky (weasel) sable hair and hand-crafted using incredibly time-intensive practices that were developed in the 1800s at the request of Her Majesty Queen Victoria herself, expect to pay a lot. And no, I'm not exaggerating; that's a real story! Not only do brushes of this quality take a long time to make, but also, the natural hair they're made with means they can hold a lot of water, which is a capability a lot of watercolorists want. There are plenty of fantastic synthetic options out there, though, and that's what I choose to use.

Don't stress about brushes. See what is available at your local art store, see what is in your budget, and know that synthetic and student-grade brushes are absolutely fine. If you want to upgrade at some stage, then go for it, but I'd upgrade my paper and paints before brushes. The main difference I found with upgrading my brushes was their shape retention, as well as their water holding capacity. Like anything, though, your personal preference will play a part. If along your journey you discover you love painting loose florals and you wish you had a softer brush, then upgrade.

PERSONAL RECOMMENDATIONS

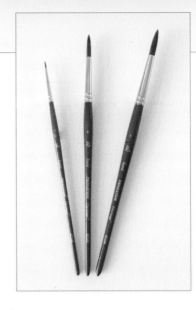

- Shape: round
- Sizes: 3/0, 6, and 8
- Brand and series: Princeton Select, Snap!, or Heritage

TIPS FOR SAVING ON BRUSHES:

- Focus on using just one shape of brush begin with.
- Decide on a few brush sizes you want to try, depending on your subject interests.
- Don't opt for natural hair, as synthetic options are more cost-effective (and cruelty-free).
- See if the brushes you're interested in are sold in packs for less.

TIPS FOR CARING FOR BRUSHES:

- When you first get your brush, it may be stiff. This generally means it's been coated with a glue to keep its shape and protect it in transit. It may even have a plastic sleeve; don't try and put that back on once you've removed it. Give your new brush a good rinse under the tap (not in your water jars) and gently swish the bristles around on the palm of your hand until they're all loosened up.
- Always wash your brushes out thoroughly after use.

- Use a brush cleaner every now and then. I recommend the Masters brand. (I used to think brush cleaners were a gimmick, but they get out an amazing amount of color from "clean" brushes. The brush soap lasts a very long time too.) You should only use a soap intended for brushes, but I'm not going to lie to you: I've used hand soap a

bunch of times! I do the same as with a new brush, and I swish it in the palm of my hand to work the color out before rinsing thoroughly.

- Swish your brush in water. Don't jam it into the bottom of your jar to clean it off.

- Don't leave brushes sitting tip-down in your water jar. This can bend the bristles, and the handle can absorb water, which will loosen the ferrule.

- When you're finished painting, don't immediately store your brushes upright, as moisture can soak down into the ferrule. Lay brushes flat in between uses until completely dry.

- If you travel, try to use a brush case that will hold them in place and protect them. I've lost count of the number of brushes I've bent in travel!

- If you've bent your bristles or if the brush has lost its nice point after a while, give it a good cleaning with brush soap. While the bristles have soap in them, gently pull them and mold them to a point. Leave the brush to sit with the soap in it, and rinse it out once it's dried. This should act similarly to the glue new brushes are coated with.

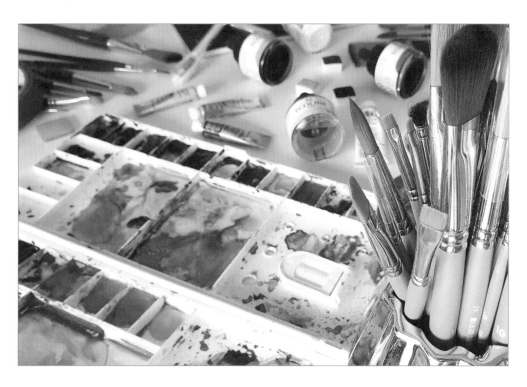

palette and mixing surfaces

Paper? Check. Paint? Check. Brushes? Check. Now we need a surface. As with every other watercolor supply, there are a lot of options for palettes and mixing surfaces. There are plastic palettes, ceramic palettes, open palettes, closed palettes, butcher's trays, handmade palettes, bulletproof palettes (not even joking), tin palettes . . . the list goes on. Choose your own adventure! These days, because I paint from home, I just use cheap dinner plates. I have a limited palette, so I really need mixing space more than anything. However, if I was always traveling, dinner plates would be way too heavy to cart around, so ask yourself what your needs are.

Do you still want to go out and buy 12 colors to start with? Get a palette with separate wells. Do you want something that you can pack away and slip into your bag? Get a folding travel palette. Do you need to paint while you fight crime? Get the bulletproof palette. The options are endless, and this one's up to you, paint pal!

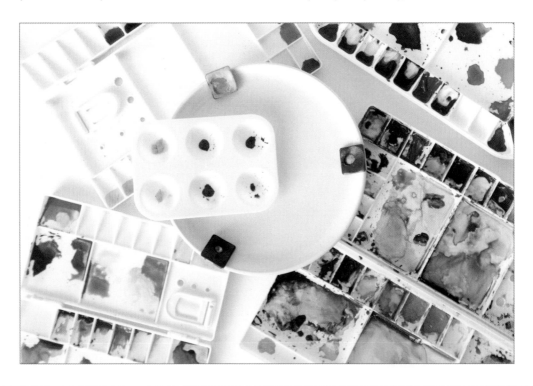

FORMAT

- Flat mixing surface
- Wells (square, round, sloped)
- Flat mixing surface *with* wells
- Open
- Folding/travel/closed
- Tins with clips to hold individual pans in place

MATERIALS

- Plastic
- Ceramic
- Glass
- Tin (coated mixing surfaces)
- Wood (coated mixing surfaces)

SETTING OUT COLORS

We all know I love a limited palette by now, but if you don't want a limited palette, then let's talk about setting out your colors on a palette. Is there a right way or a wrong way to organize colors on a palette? Of course not! There are just lots of schools of thought, as usual.

Here are some options:
- ROYGBIV (rainbow order: red, orange, yellow, green, blue, indigo, violet)
- Warm and cool (clear separations on the palette: reds, oranges, and yellows on one side; purples, blues, and greens on the other)
- Light to dark (white, yellow, orange, red, pink, purple, blue, green, brown, black, gray)
- Color families (keep yellows together, oranges together, reds together, etc., and keep a well of separation between them)
- Brights and neutrals (vibrant colors together, muted colors together)
- Literally any way you want!

PERSONAL RECOMMENDATIONS

- Plain white dinner plates (can't go wrong; just don't ever eat off them again)
- A plastic folding travel palette if you're on the move a lot (any brand)

TIPS FOR SAVING ON PALETTES

- Think about your needs first. This can be difficult, as sometimes we don't know what our needs are until we've been doing something for a while, so if you're not sure, just go for something cheap first. But if you already know you'll barely be at home to paint, don't go and buy a bunch of heavy dinner plates to mix on. Likewise, if you know you want to paint with pans, don't buy a plastic palette, because you won't be able to put that paint in the wells.
- Look online for palettes, especially if you're opting for a plastic palette, to check prices.
- Don't dispense too much paint onto your palette too soon. It can be so satisfying to squeeze every last drop of your tube paint into a new palette, but if you're brand new to watercolor, you're probably going to change your color layouts and even the colors you love most. Start small, so you can change things up easily!

TIPS FOR CARING FOR PALETTES

No matter what type of palette you choose, make sure to give it a good cleaning before loading it with colors or mixing on it. Check the cleaning instructions, but if you've opted for a plastic, ceramic, or glass palette, you should be able to give it a good wash with warm soapy water. Just make sure to properly rinse and dry it so your paint mixes won't get contaminated.

If you choose a plastic palette, you're probably also going to find that when you start

mixing on it, the paint beads up instead of sticking flat to the palette. This is because watercolor and plastic were never meant to be friends. This will stop once you've layered enough paint onto the mixing areas, but you can prevent the beading from happening in the first place by gently scrubbing the plastic the first time you clean it. If you have a slightly abrasive sponge, rub it all over the surface until you notice the plastic stops being so shiny and instead looks a little dull. No need to shred it! Just take away that sheen, and your watercolors should stick.

Other supplies

Water jars
Every watercolorist you talk to probably has a different preference when it comes to water jars. Some use one giant tub for everything. Some use two: one to wash off the paint and the other to collect fresh water. Some use three: one for warm colors, one for cool colors, and one for fresh water. Do whatever works for you!

I prefer two jars (one for warm colors and one for cool), as it prevents the water from turning brown. I also use glass jars, as they're a little heavier and harder to knock over by accident.

Paper towels
Paper towels are one of the most helpful supplies when it comes to painting with watercolor. They're good for dabbing brushes on, cleaning brushes, testing colors, cleaning up messes, fixing mistakes, and creating fun effects. I tend to grab the cheapest brand I can, as I go through a lot of paper towels. Feel free to look into other alternatives, such as old clothes or rags.

Painter's tape
There are lots of different tapes out there, but I've had the most success with blue painter's tape. I highly recommend doing a test on a scrap piece of paper by applying

tape, painting color and water all over it, letting it dry, and trying to remove it. When you remove tape, pull it off nice and flat to avoid tearing, and go slow. If you find that the tape you've got is too sticky, try dabbing a fresh piece of tape onto your pant leg before taping your paper down. This can help remove some of the adhesive.

Light pad

A luxury optional extra, but very handy if you regularly trace subjects. I paint a lot of animals and love to trace photos to get them super realistic. A light pad is essentially just a flat, electronic device that emits bright light to penetrate through paper, so you can see through it. I'm still using a 2016 Huion A3 light pad. There are cheap alternatives these days, and you can also DIY a few options too.

Heat gun

Another item I couldn't live without is a heat gun. The one I use is an embossing tool, so it blows out extremely hot air but not at high force. This is great for watercolor because if the force was too strong, it might blow color around. You could try a hair dryer, but be aware of the force factor. I actually used to take my paintings and stand in the bathroom, holding them up to the ceiling heat lamps to dry them faster. Gotta do what you gotta do!

Masking fluid

Masking fluid is a liquid latex that you can apply to your paper, let dry, and then peel off to reveal the preserved paper underneath. Though I personally do not enjoy using it, it's a really popular watercolor product, so it would be remiss of me not to mention it. The reason I don't like it is that it doesn't play well with heat guns and really needs to air dry; otherwise, it can bond to the paper and tear it up. However, many

artists swear by masking fluid. If you ever become frustrated that paint flows into an area you were intending to keep empty, consider it.

Washi tape

Washi tape can sometimes take the place of painter's tape, but it's not always as strong, or as friendly when you remove it from your paper. It's best to test it on scrap paper first! I love washi tape for things like color charts because you can buy it in really thin rolls. It's definitely not necessary, but if you find yourself wanting to "mask off" areas of your paintings or

create straight lines that you can peel off within your painting, it might be worth a go.

Pencil and eraser

I use a Staedtler Mars technico mechanical pencil because it comes in 2 mm lead. I love it for sketching on watercolor paper, as it doesn't etch the surface like thin-

ner leads can. There are many good options, though, and I recommend any type of H (hard lead) pencils that stay nice and light, allowing you to easily erase your sketch. I like mechanical (click-down) erasers for their precision.

Metallic watercolors

I don't use them often, but it can be fun to have metallic watercolors in your kit. Whether you're adding a bit of shimmer to snow capped mountains or painting solid gold coins, it's a fun optional extra! I use The Watercolour Factory paints, but I also love Winsor and Newton iridescent medium, as well as any of the Coliro metallic watercolors.

setting up your workstation

When it comes to watercolor, timing is everything. If you wait too long or not long enough, you risk not being able to add to your painting the way you wanted to. One way we can ensure that we are ready to act at the right time is to set our workstation up for success.

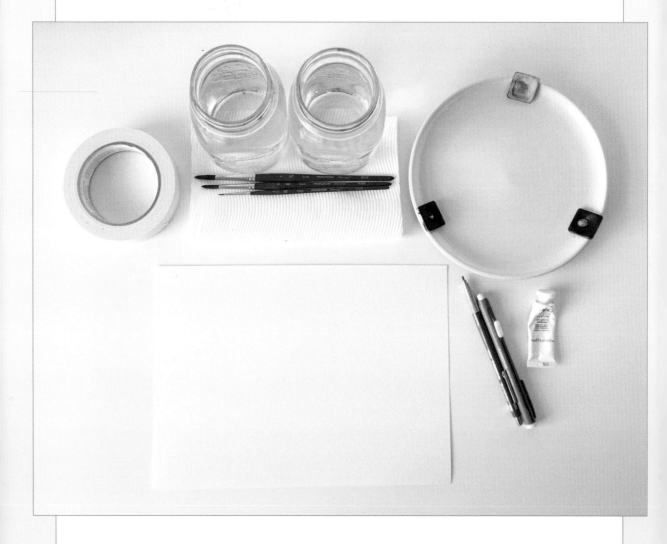

Here are my top tips for setting up the most productive and comfortable workstation:

- Have a stable surface to work on. I recommend a flat table rather than an easel or tilted surface, so that your watercolor doesn't run out of control down the page. You may want to consider a moveable board so you can tape your paper down but still turn and move independently of the table surface.

- If you can, use a table that's the right height for you. I'm 5'10" and once worked a job where the chair sat me too high for the table. I sprained my back. Don't be me.

- If you can, use an office chair with a five-spoked wheeled base and no arm rests.

- Once seated, your elbows should be able to form a 90 degree angle when you rest your forearms on the table, and you should be able to comfortably plant your feet on the floor.

- Make sure to take plenty of stretch breaks if your workstation isn't set up for long periods of sitting and painting comfortably. It's a good idea to take regular breaks even if it is set up properly.

- Try to use good lighting that doesn't strain your eyes, natural or artificial.

- Keep as many supplies as you can that you'll be using regularly in your optimal reach zone, which means you don't have to stretch to grab them from a seated position.

- Make sure you've got enough paper towels so you don't need to rush off mid-painting.

- Each time you are about to start working on a new layer, double check that you've got clean water and enough of anything else you'll need.

- Before you start a layer, pre-mix your colors so you're not rushing to mix them while your layer starts drying.

color theory

Color *theory*. Sounds boring, right?
Let's make it fun and practical.

Color theory is the first thing I ask my students to understand when learning about watercolor. So often newbies (myself included when I was starting) jump straight into full paintings. We have no idea what will happen when certain colors mix on the palette or paper. We often try to use too many colors. We put colors next to each other that simply don't look right, or fight each other for attention. We end up with a bunch of paints we don't even use, that we just bought because we thought we needed them. We become frustrated, and many beginners give up at this point.

The reason I love color theory and color mixing so much is that they make everything much simpler, and provide structure that gives you a starting point to work from before letting loose. Fewer colors. More control. Less feeling overwhelmed. More confidence. Less mud. More harmony.

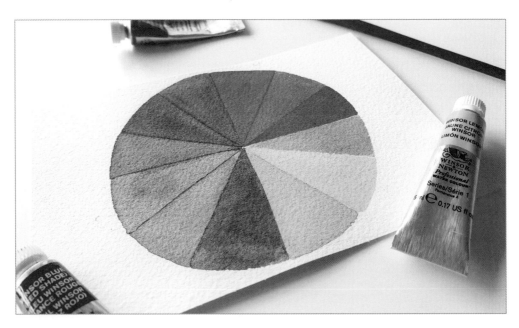

Mixing from a handful of colors is often referred to as using a **limited palette**. Here are some pros and cons of this technique (as you may decide later that you'd prefer to buy each color instead):

PROS TO A LIMITED PALETTE:

- Saves you money, only requiring three colors instead of 12 (or more)
- Teaches essential painting and mixing skills
- Gives you the freedom and ability to mix whatever colors you need in future
- Helps develop an understanding of how colors work together
- Creates a harmonious palette, where all colors relate to the original three

CONS TO A LIMITED PALETTE:

- Mixing is more time consuming than using paint straight out of a tube or pan.
- The more you mix a color, the less pure it becomes (and often more diluted due to extra water).
- You have to re-mix the color you need from scratch when you run out.
- You may feel as though you run out of paint quicker, as you are continually using the same three colors.

For now, we will focus on the 12-color wheel, color properties, and color schemes for achieving harmony.

Before we jump into our first color theory activity, let's learn how to actually mix colors depending on the type of watercolor you're choosing to paint with.

how to mix colors

So how do we actually mix watercolors? Is there a right way or a wrong way? It really depends on the type of watercolor you're using. Watercolor comes in several different forms: tubes, pans, liquid, pencils, markers, crayons, and more. I highly recommend you use either tube or pan watercolors. To me, using pencils, markers, or crayons just adds extra steps. They all have their uses, though, and watercolor pencils are a great alternative for tracing sketches, as they'll disappear into your painting, unlike a lead pencil.

I also prefer to steer clear of liquid watercolors, but that's just me. They're dye-based, and I find them too intense, making it harder to control dilution and saturation. They sink into the paper and stain it quite quickly, making them more difficult to work with. They're also generally not lightfast, and they can't be reactivated on a palette like tube and pan watercolors. Some painters love working with them, however. I have included instructions in the following pages on how to mix with them, in case you do enjoy them.

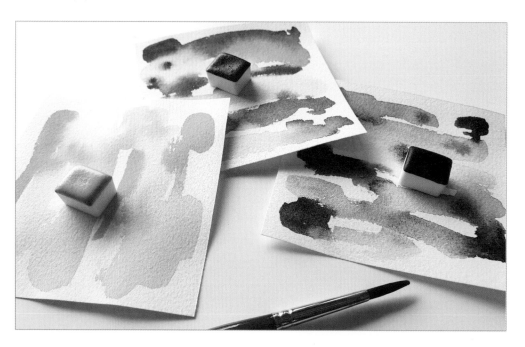

MIXING WITH TUBE WATERCOLOR

Tube watercolor comes sealed in a tube with a cap and is "fresh." This means that when you squeeze the paint out, it'll be soft and moist. To use it, you can squeeze it onto a palette, load your brush with water, and mix it, transferring the diluted color to your brush. The neat thing about tube watercolor is that you can squeeze it out wherever you like, so you could put a dab of yellow and a dab of blue right next to each other on your palette, and mix them with your brush to create a very saturated green. I quite like creating color wheels with tube watercolor for this reason. It's very strong (or "saturated"), and being moist already, it doesn't take much water to activate.

However, on a day-to-day basis, I recommend having a palette with wells that you can squeeze some paint into and let dry, effectively turning it into pan watercolor. When creating regular paintings instead of super vibrant color wheels, fresh water-color from the tube can be too strong and easy to waste. To make paint last a little longer and to have better control over the strength, squeeze colors into a palette and leave them to dry for 24 to 48 hours. It is not uncommon for dry tube watercolor in a palette to develop cracks, and shouldn't affect your painting. Adding a drop or two of glycerin can help.

MIXING WITH PAN WATERCOLOR

Pan watercolors come in little containers and are dry. To activate them, you need to load your brush with water and rub it across the top of the pan. Some people dislike pan watercolor because of this, as it can wear out their brushes with the scrubbing, and they only like to use moist tube watercolor. I personally prefer pan watercolor (or dried tube watercolor) because it helps me to control the colors' saturation. You can just use a little bit of water for a saturated mix, or add more water to dilute it. If you're worried about the friction on your brush when activating, mist your pans or dry tube watercolors with a water spray bottle and let them soften for a couple of minutes. This pre-moistening will mean you don't have to rub your bristles as much over the paint.

To mix pan watercolors together, we need to pick them up on our brush and transfer them to somewhere on our palette, then do the same with the other colors. Mixed pan watercolors therefore tend to be more dilute. This is where tube watercolor can be handy if you love saturated color. Because you're not using extra water to activate, collect, and transfer colors with your brush, you can dab fresh tube watercolors next to each other.

MIXING WITH LIQUID WATERCOLOR

Like I said, I'm not a fan of liquid watercolors, but one reason people may prefer them is that they often come in bottles with droppers. This means you can very accurately create mixes with exact ratios, something almost impossible with pan or tube colors. It is best to use them with a palette that has wells, as their consistency is very watery. You can use the droppers to add color(s) to a well, and combine with your brush.

Note: When you use dried watercolor and accidentally add too much water to your paint, you can remove excess water with your brush or even a bit of paper towel. You can't do this with liquid watercolor, as water combines with the paint immediately.

Now that we know how to mix with watercolors, let's get our wheel on!

color wheel

The first activity I have my students do with their paints is create a 12-color wheel from the 3 primary colors: red, yellow, and blue. This is a great introduction to color theory and becoming comfortable with mixing your own colors.

The aim is to use our three primary colors to create three additional secondary colors: orange, violet, and green. From those, we create an additional six tertiary colors: yellow-orange, red-orange, red-violet, blue-violet, blue-green, and yellow-green.

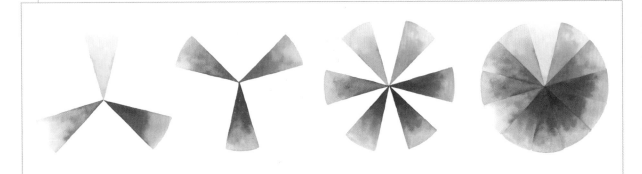

Before we get too carried away, let's talk about the primary colors. Back in school you may remember learning about the primaries: red, yellow, and blue. Maybe you even learned that "you can't make these three colors from any others," but "these three colors can make all others."

There's been a shift in what colors make up the primaries. Yellow, red, and blue are traditional, whereas the modern primary colors are considered yellow, magenta, and cyan (like the ink colors in a printer). These have become the "go-to," as they provide a much wider and more vibrant range of colors when mixed together. I mix all of my colors from the modern primaries. The "red" that I use is a magenta, and the "blue" that I use is a little more on the turquoise-y side. For the sake of simplicity, I will still refer to them as yellow, red, and blue.

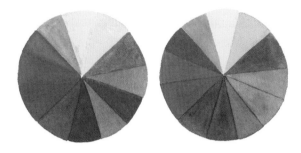

Traditional vs. modern color wheel

Here's a summary of how we go from three colors to 12, with some rough ratios for mixing:

Primary colors:
- Yellow
- Red (or Magenta)
- Blue (or Cyan)

Secondary colors:
- Orange (50/50 Yellow + Red)
- Green (50/50 Yellow + Blue)
- Violet (50/50 Red + Blue)

Tertiary colors:
- Yellow-Orange (75/25 Yellow + Red)
- Red-Orange (75/25 Red + Yellow)
- Red-Violet (75/25 Red + Blue)
- Blue-Violet (75/25 Blue + Red)
- Blue-Green (75/25 Blue + Yellow)
- Yellow-Green (75/25 Yellow + Blue)

Note that the ratios above are a **guide only**. It's almost impossible to measure exactly how many drops of color you are adding to the mix, and all brands and pigments will have different strengths, but as a rough guide, aim for the ratios listed. If you find that your yellow + red mix looks too red instead of orange, for example, simply add more yellow to adjust it. It's not a perfect science, and a lot of color mixing is going "by eye." If you find yourself having to deviate greatly from the ratios listed above,

simply make a note on your color wheel of how you achieved that color for future reference. The aim of the wheel is to create 12 different colors. We don't want two to look the same simply because we're being rigid about the ratios. I cannot stress this enough, as I see many students get way too hung up on getting the "exact" ratios in their mixes. Focus instead on achieving a wheel that resembles the example below.

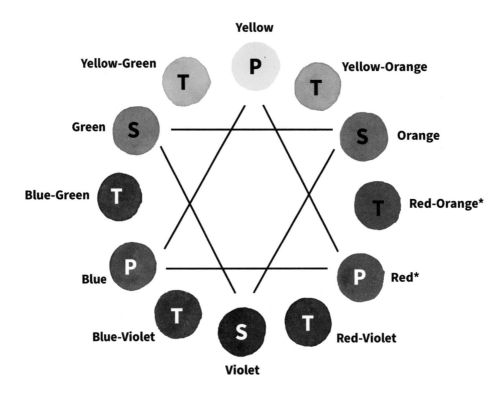

*Red-Orange: should look like traditional red
*Red: this is our "primary red" that is actually magenta

P: PRIMARY: **100%**
S: SECONDARY: 50% of each primary (roughly)
T: TERTIARY: 75% of closest primary, 25% of second closest primary (roughly)

Materials:

- Color wheel template
- Pencil and eraser for tracing template
- Watercolor paper
- Watercolors in the three primary colors (refer to Materials on page 25 for primary colors)
- A watercolor brush (mid-sized or 6-10 round brush is easiest, but use what you have)
- Palette with plenty of mixing space

Step 1: Trace the color wheel template, or freehand it if you like.

Step 2: Label your 12 circles, starting at the top and going clockwise: Yellow, Yellow-Orange, Orange, Red-Orange, Red, Red-Violet, Violet, Blue-Violet, Blue, Blue-Green, Green, Yellow-Green.

Step 3: Paint in Yellow, Red, and Blue using your primary colors.

Step 4: Now that we have painted in our primary colors, we need to mix our secondary colors. Do this by creating three additional puddles on your palette. Make the puddles big enough that after you paint them on the wheel, you'll still have enough paint to create two additional colors with them (the tertiaries). Mix roughly 50/50 of Yellow + Red to get Orange, Red + Blue to get Violet, and Blue + Yellow to get Green. Adjust the ratio if they're not looking enough like an Orange, Violet, or Green.

Step 5: Once you have mixed up three puddles of Orange, Violet, and Green, paint them on the chart in their respective circles.

Step 6: Now that our primaries and secondaries are painted, it's time to make our tertiaries! We can make the tertiaries from the existing puddles of secondary colors we just mixed up. Use the Orange puddle to create Yellow-Orange and Red-Orange by adding some extra Yellow to one side for Yellow-Orange, and some extra Red to the other side of the puddle for Red-Orange. The aim is to make sure that Yellow, Yellow-Orange, Orange, Red-Orange, and Red all look different enough from each other on the wheel. This is the same for the other sides of the wheel too. Using the Violet puddle, add extra Red to one side for Red-Violet, and extra Blue to the other side for Blue-Violet. For Green, add extra Blue to one side for Blue-Green, and extra Yellow to the other side for Yellow-Green.

Step 7: Paint in the tertiaries on the chart, and you're done!

Congratulations on painting your first color wheel! You're well on your way to learning how to mix any color you need.

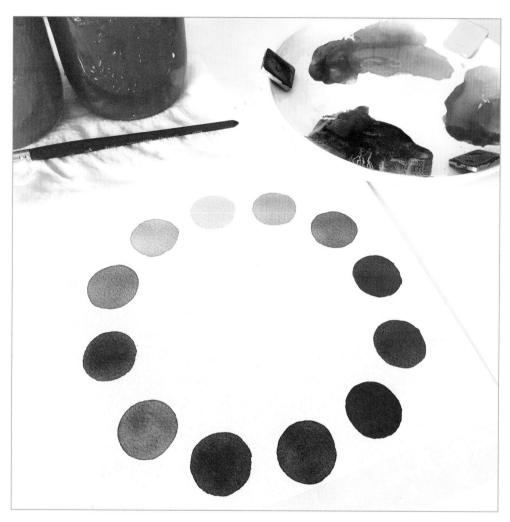

Video Instructions

If you're having trouble understanding the process of creating the color wheel, please jump over to my online school thewatercolouracademy.com and sign up for my free Color Theory 101 class, where you'll find video instructions for the color wheel. If you really want to challenge yourself and learn how to turn your three primary colors into 144 colors, you'll also find a fun color charting lesson in there, too.

color properties

I know, I hear you: "When will we get to the painting?!" Soon. But before we do, I want you to familiarize yourself with the following properties of watercolors, because there's even more we can do with the twelve colors we've made. There's also a bunch of terminology you'll see me use throughout the book, and this section will define those terms.

PROPERTIES AND USEFUL TERMS

HUE, SATURATION, AND VALUE

We describe colors using three characteristics: hue, saturation, and value.

Hue: Describes what color something is.

Saturation: Used interchangeably with the words "intensity" or "chroma." Describes a color's dullness or intensity.

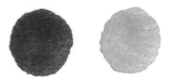

High saturation vs. low saturation

Value: A color's lightness or darkness.

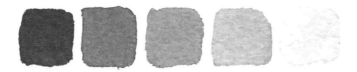

TRY IT: Create a value chart (like the one above) using any color(s). Start with the most saturated version of that color, and add a bit more water to each square until you achieve the lightest version of that color. See just how far you can stretch one color!

MASSTONE AND UNDERTONE

Masstone is paint straight from the tube or pan in its most concentrated form, and undertone is the same color or pigment watered down or in its thinnest layer.

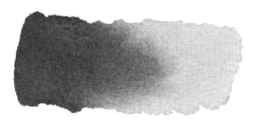

TINTS, TONES, AND SHADES

Using white, gray, and black, you can stretch a single color even further by creating tints, tones, and shades.

+ = TINT

+ = TONE

+ = SHADE

NOTE: *You can use water to lighten a color in place of white,*
you can mix all three primaries together to create black, and you can
add water to your new black to create a gray (more on this later).

TEMPERATURE

Color temperature can be broken down as follows:

Warm: yellow, yellow-orange, orange, red-orange, red, red-violet
Cool: violet, blue-violet, blue, blue-green, green, yellow-green

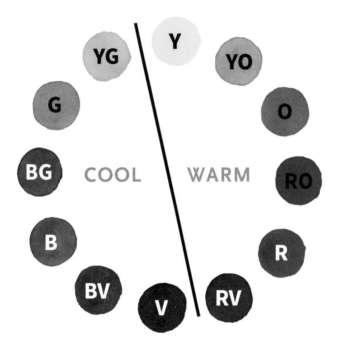

However, individual colors can also have a cool or a warm bias. For example, Scarlet Lake is usually seen as having a warm bias, and Permanent Rose is usually seen as having a cool bias. These are very slight biases. It is important to note that temperature is relative, and a hue can be seen as warm compared to one color, yet cool compared to another. Warm and cool biases are the reason that some mixes work and some turn to mud. The best way to learn more about how colors interact is to play around and create swatches that show you how different colors look when mixed together.

*Winsor Blue (red shade) +
Permanent Rose*

*Winsor Blue (red shade) +
Scarlet Lake*

SPLIT PRIMARIES

You may have heard about split primaries in your watercolor adventures so far. This means that instead of a regular color wheel starting from just yellow, red, and blue (like we made in the previous section), the wheel includes a cool yellow, warm yellow, cool red, warm red, cool blue, and warm blue.

Depending on which pigments you used, you may have created some muddy colors when making your color wheel. This could have been because, according to the split primary method, you mixed colors that "cross over" into a different third.

The idea behind split primaries is to mix colors in a specific way to get the best results, splitting the color wheel into three areas:

- Warm red + warm yellow = orange
- Cool yellow + cool blue = green
- Cool red + warm blue = purple

Winsor Yellow (warm yellow)

Winsor Lemon (cool yellow)

Winsor Blue (green shade) (cool blue)

Scarlet Lake (warm red)

Permanent Rose (cool red)

French Ultramarine (warm blue)

By mixing in this way, we can achieve the most vibrant secondaries. That's not to say that we can't stick to our regular old recommended primaries (they work pretty dang well on their own). But split primaries offer a sure-fire way to prevent muddy, dull, or uneven mixes.

By looking at the chart on the previous page, can you see the slight differences that make a color "cool" or "warm"? Remember, it's all relative to the color it's next to. If we look at Winsor Yellow vs. Winsor Lemon, Winsor Lemon looks cooler than Winsor Yellow. (And not just because it's wearing its favorite leather jacket.)

The color mixes in the center show what happens when we "cross over". Warm yellow + warm blue = less vibrant green, cool blue + warm red = really muddy and dark purple, and cool red + cool yellow = less vibrant orange.

TRANSPARENCY AND OPACITY

Transparency describes the ability of a color to allow a layer under it to show through.

Opacity is the opposite of transparency, and describes the ability of a color to cover up layers under it.

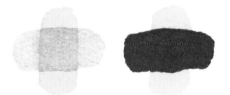

MIXING BLACK

When you mix the three primary colors of yellow, red, and blue together, you create black. This is a combination you would not have discovered when we made our color wheel, but is yet another way you can save on paint by sticking with the three primaries. Mixing black isn't always easy. If you're using tubes, try putting a dot of each primary color right next to each other on your palette, then mix them all at once. If you're using pans, bring some of each primary color to an area on your palette, then mix all at once. If you mix yellow and red first, then add in blue, you'll get brown because yellow and red make orange, and orange and blue are complementary

colors (opposite each other on the color wheel) and will simply neutralize each other. It's important to mix them all at the same time.

TIP: Create gray by adding water to your black mix and diluting it.

TRY IT: Create your own black by mixing all three primary colors. Then, using water, create gray(s) from your new black.

MIXING BROWNS AND NEUTRALS

Expand your palette even further by creating different browns and neutrals. These can be created by mixing complementary colors with one another. Complementary colors sit opposite one another on the color wheel, and are therefore the most visually contrasting of the color schemes you can use. (More on color schemes next.) However, if you happen to mix them, they will create muddy and brown colors. You can use a very tiny amount of the opposite color to dull down the intensity of its complement.

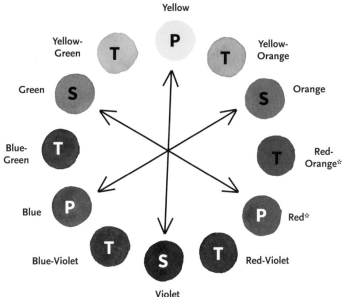

P: PRIMARY: 100%

S: SECONDARY: 50% of each primary (roughly)

T: TERTIARY: 75% of closest primary, 25% of second closest primary (roughly)

Neutrals in the center are created when mixing the color above with the color below.

TIP: Stretch neutrals further by adding water (in place of white) or black (created with your three primaries) to alter their values.

TRY IT: How many browns and neutrals can you make from your complementary colors?

color schemes

This section will help you learn how colors work when used together, and understand how to choose colors for future palettes and color schemes. The best way to learn is by trying and making mistakes, learning what works and what doesn't work. Please do not aim to replicate exact results on the following pages, but instead get to know your supplies, experiment, and most of all, have fun!

TIPS:

- Prepare all of the colors you'll need for your color scheme before you start painting.

- If you are right-handed, work from top left to bottom right, moving back and forth across and down the page. This will keep your hand out of the way and help you avoid touching wet paint. Lefties, do the opposite.

- The aim of this particular pattern is for the circles to touch each other and bleed into one another. For this to happen, you need to work quickly, before the paint dries.

- The more water you use, the farther the paint will spread. If you only want slight bleeds, use less water in your circles, or wait for them to dry a bit before starting the next circle.

- The best bleeds happen when your circles touch right at the end. Once you have one circle painted, begin painting the one next to it, but leave the "touching" part until the end. This will allow the two circles to bleed into each other in the most natural way, instead of you having to spread the colors around to finish the second circle.

- If you find painting your color schemes in circles too challenging, you're welcome to use any other pattern! Just try to have some colors saturated and some diluted, so you can see the effect that value has on color schemes. Colors may not always look good together when they're all heavily saturated, or all heavily diluted, so try to include a combination.

COLOR SCHEMES

Monochromatic: Use one color throughout, and create different variations of that color using tints, tones, and shades.

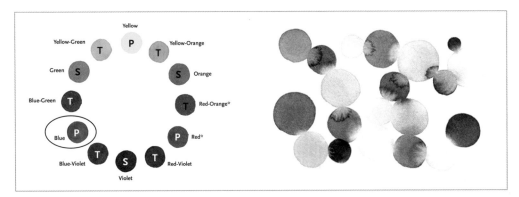

Analogous: Use colors that are next to one another on the color wheel.

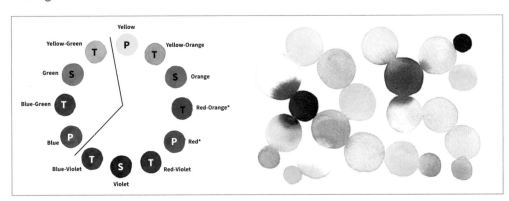

Triadic: Use three colors that are an equal distance from each other on the color wheel.

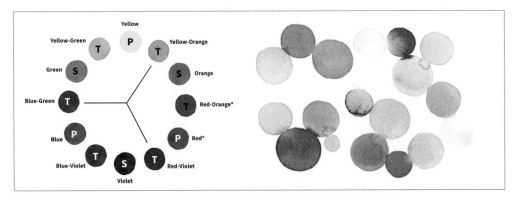

Complementary: Use colors that are directly opposite one another on the color wheel. This is the most contrasting of all the schemes, and is best used when one color is more prevalent than the other.

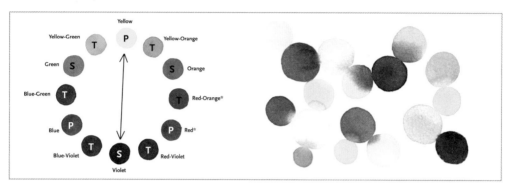

Split Complementary: Instead of using colors directly opposite one another, choose one color, then use the two colors either side of its complement.

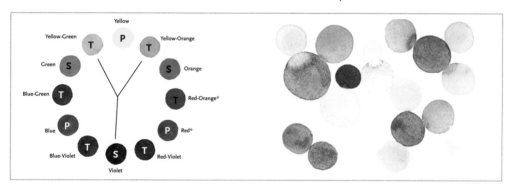

Analogous Complementary: Same concept as the previous scheme, but also include the complementary color.

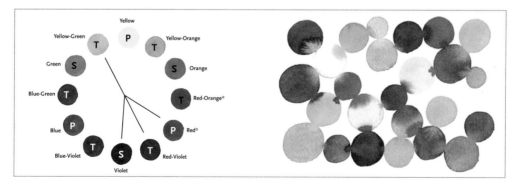

Tetrad: Use four tertiary colors, two on either side of a complementary pair.

NOTE:

- The more colors we add to a scheme, the more overwhelming a piece can become—refer to the Analogous Complementary scheme on the previous page. The colors in that example are highly saturated and are competing with each other. It's important to remember we can tint, tone down, and shade our colors like we learned in Color Properties (see page 55).

- A simple way to add contrast is to use water. The following example follows the same Analogous Complementary scheme, yet has some less saturated circles to balance the piece more and not hurt our eyeballs.

- Don't forget: Watercolor can also be layered. If you're unsure what to saturate, start light and then slowly build up your colors.

- A helpful activity many artists use when choosing a palette is to paint the colors next to each other to see if they'll work.

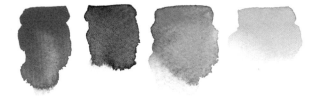

- You can take this a step further by using value charts (see page 54). By charting each color, you can place the squares next to each other at varying lightness and darkness to see how they work together.

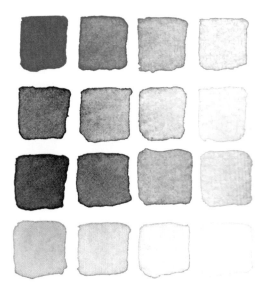

These are some of the most commonly relied on color schemes that you can use to create visual harmony in your paintings, but they aren't the only ones! Use your color wheel to try these out, as well as discovering new possibilities.

Try adding in some of your neutrals from page 59, or tint, tone, and shade some colors to see what effect that has on your overall scheme.

Techniques

We've now learned about the supplies used for watercolor, color mixing, color theory, properties of color, and color schemes. The last things we need to experiment with before we start trying to create paintings . . . are techniques!

Techniques are some of the most exciting things about learning watercolor, because they're where the medium shines and shows its unique features. The way watercolor can be opaque or totally transparent. How it can layer, blend, bloom, run, and create a myriad of yummy textures. There are lots of techniques and lots of ways to use them to make our subjects come to life, so let's jump in!

WATER RATIOS

One of the trickiest parts of watercolor is learning how to adjust paint and water ratios, and to achieve the paint consistency we need. "Ratios?" I hear you ask. "I thought we left that junk in color theory!" Not quite, but don't worry. There's no math involved here.

"So, why are ratios still a thing I need to think about? Can't I just grab my brush, dip it in some color, and paint with reckless abandon?" You could, and that does sound pretty fun. When we talk about ratios in watercolor painting (not mixing), we're talking about the ability to control our paints by knowing how much water versus paint we need on our brush, palette, or paper. It's often an overlooked part of learning watercolor (because let's face it, pretty color wheels and getting straight to painting things are way more exciting than anything with the word "ratio" in it), but it's absolutely critical. Most roadblocks beginners run into with watercolor can be traced back to ratios.

When we need to think about ratios:
- When we dip our brush into water and take it out
- When we dab our brush off on a paper towel
- When we use a wet brush to activate our watercolors
- When we use a brush to pick up color
- When we place our loaded brush onto paper
- When we manipulate and move paint on paper

As you can see, it's pretty important for every part of painting with watercolor.

When we get our ratios wrong, here's what can happen:
- Our brush has too much or too little water on it
- We mix a far too diluted or much too opaque color
- We pick up too much or not enough paint on our brush
- The paint doesn't flow enough, or flows too much on paper
- We create unwanted effects like harsh lines or blooms

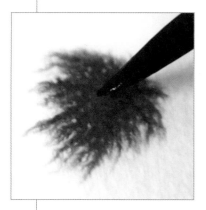

LOADING YOUR BRUSH WITH WATER

When painting, you generally won't want your brush so wet that it drips everywhere. When dipping your brush into your water jars, use the lip of the jar to swipe any excess water back into the jar. You can also gently touch the brush on some paper towel and let it soak up the excess. When you look at your brush, you should be able to hold it up without it dripping and see a nice sheen to the bristles. If the bristles are all splayed out, your brush may be too dry.

ACTIVATING WATERCOLORS, PREPARING YOUR MIX, AND LOADING YOUR BRUSH WITH PAINT

If you're simply using your brush to carry water from the jar to your palette, it's okay to have a super drippy brush. Some artists mist their palette with water to activate their colors, but I prefer using my brush, so that's one occasion when I would have a very wet brush. However, if you're hoping to get a really rich and opaque color, you won't want to carry too much water across to your palette. The more water we add, the more diluted the color will become. While learning, it's a really good idea to have a scrap of paper nearby so that you can test your paint before you apply it to your

final painting. This will allow you to see how it flows and how opaque or translucent your paint is.

 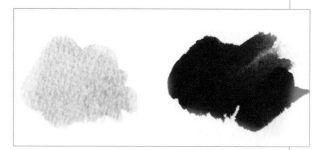

WHEN PUTTING BRUSH TO PAPER

Luckily it's not too hard to tell whether we have overloaded or underloaded our brush with water when we start painting! If you put the brush down on paper and a really thick, paste-like mess with visible bristle marks comes off, you'll need some more water on your brush to make the paint flow. Dip it in your water jar (without swishing) and gently dab off any excess water on the lip of the jar or paper towel.

If you put your brush down and a big blob of water appears to be sitting on the paper surface, you may have too much water on the brush. Gently dab your bristles on some paper towel to soak up the excess and try again. Check out pages 73–77 for more about painting directly onto paper as well as onto an already wet area.

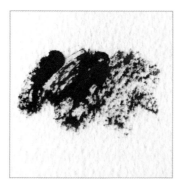

YOUR BRUSH IS BASICALLY A HOUSEHOLD CLEANING APPLIANCE

One way to wrap your head around the relationship between the brush, paper, and paint is to think of your brush like a vacuum cleaner when it's very dry and a leaf blower when it's very wet. When our brush is pretty dry (either with or without any color on it) and we dab it on an area of water on our page, it will suck the water right up like a vacuum! This can be helpful when you want to fix a mistake or just soak up excess water or color.

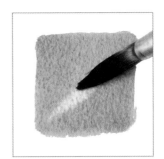

However, when our brush has too much water on it, it'll act like a leaf blower and spread that stuff everywhere. Both the vacuum effect and the leaf blower effect are great to know how to do, but generally we want to operate somewhere in the middle, so make sure to swipe or dab off any excess water before putting brush to paper.

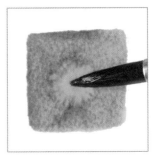

GETTING THE RIGHT PAINT CONSISTENCY

This is another thing that will depend entirely on what you're trying to paint. It's okay to have a very opaque mix if you need concentrated color, and it's also perfectly fine to have a super watery and diluted color. More often than not, we want to try to find the middle ground between watery and thick. You can usually feel the resistance on your brush when mixing if the consistency is too thick. On the other hand, the mixture will be thin, transparent, and runny if there is too much water in the mix. If your mix is too thick, just add water! If your mix is too watery, you can try either removing some of the water by picking it up with your brush and dabbing it on a paper towel, or adding/activating more paint.

TRY THIS:

If you've got a tube of watercolor, squeeze a blob of it out onto your palette. With a damp (but not sopping wet) brush, pick up some of the color and paint a square onto your page. The paint will be super thick, paste-like, and probably very dark in color. Now dip your brush into your water jar and bring over a little bit of water. Start

to dilute the blob of paint. Paint another square on your paper next to the first one. Continue this process until you get the color as light as possible. This will both give you a mini-lesson in value (lightness and darkness of that particular color) and show you what the paint will look like when it's thick or watery. Note anything you want to remember, such as the point at which you felt you had more control over the color and water.

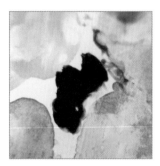

HOLDING THE BRUSH

Now that we know a little bit about loading our brush, let's talk about using it.

There are plenty of ways to hold your brush that will achieve many different results, so rather than tell you the "best" way (because that's subjective), I'll give you some general tips:

- Try to keep a gentle but controlled grip on your brush. No death grips!

- You can maneuver your brush around like a pencil. It doesn't need to be held in one position or angle like a calligraphy pen. Instead of a nib, it has bristles that can splay out in all directions, meaning we need to exercise a bit of control.

- Experiment with the position of your hand up the handle. I don't recommend holding the brush by the ferrule (the metal piece just above the bristles), as it is an important connector, but anywhere above the ferrule all the way to the end of the handle is fine. The farther up the handle you hold the brush, the less control you will have. This can be fun to play around with to paint in a looser style. The closer to the ferrule you hold the brush, the more control over your strokes you'll have, which comes in handy for detail work.

- Experiment with your grip on the brush. Try painting while holding it in your natural style, then try holding it like you'd hold a pen, or try pinching the handle with a finger and thumb, or like you are about to conduct an orchestra. See what type of brush strokes you get from each grip.

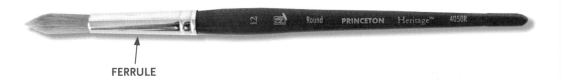

FERRULE

TRY THIS:

Hold your brush in different positions and grips, and paint some strokes on paper. See what results you get and what feels most natural!

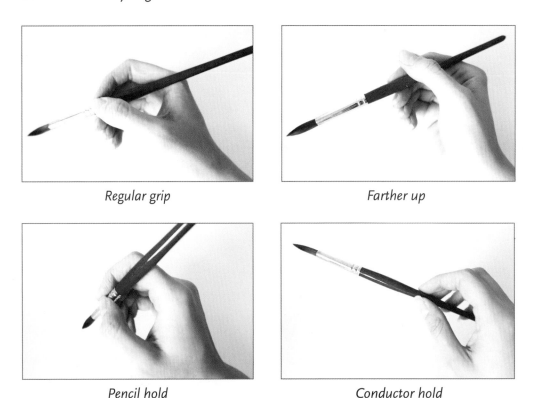

Regular grip *Farther up*

Pencil hold *Conductor hold*

WET ON WET

One of my absolute favorite techniques is wet on wet. This is whenever we add paint and water to an already-wet part of our page with our brush. This technique can create some crazy blends and effects as the water and paint rush out of the brush onto the wet page. I love painting with wet on wet because it's a softer way to paint. Painting on an already wet area dilutes colors. This also makes the watercolor more forgiving than if we painted it directly onto a dry page. Wet on wet allows us to correct mistakes a lot more easily because the color hasn't soaked into the paper yet.

You can use this technique on a clear area of water, or an area of paint. The longer you let the water on the paper dry, and the less water and paint on your brush, the less wide-spread the bleed will be. The combination of a wet page and a fully loaded wet brush is what causes this rush of paint and water onto the page. We are essentially flooding it. But remember, watercolor can only travel as far as there is water on the page, so although we lose some control with this technique, we can set boundaries as well. We can also use our brush as a vacuum to suck up any mistakes or bits we don't like!

TRY THIS:

Paint a wet area onto your page. Load your brush with plenty of paint and water and drop it directly into that area. Watch how far it spreads. Try it again with less moisture on your brush and see how that changes the explosion effect.

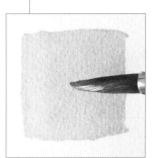 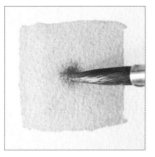 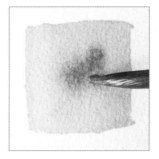 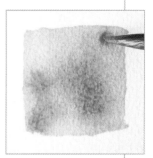

WET ON DRY

Wet on dry is the standard and most common painting technique, where we apply a brush loaded with water and paint to dry paper. This technique gives us more precision than wet on wet, but it's a little less forgiving. When we apply paint to dry paper, it is more likely to stain permanently than if we had dropped it onto a wet area. However, we're also able to exercise a lot more control with this technique, as well as achieve more saturated colors, because there isn't extra water on the page to dilute them.

There are many brush strokes we can experiment with when painting wet on dry.

TRY THIS:

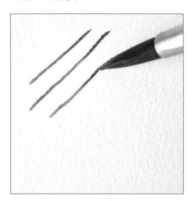

Thin lines
Load your brush with paint and hold it very upright. Paint lines across the page while trying to control the brush and keep the line consistently thin.

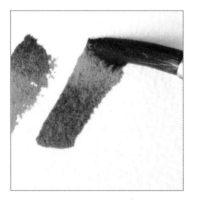

Thick lines
Load your brush with paint and hold it angled down. Paint thick lines across the page using the belly of the brush and try to keep the thickness consistent.

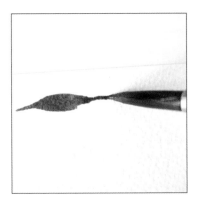

Thin to thick to thin

Using a combination of the above two exercises, paint a line across the page and alternate between thin and thick lines by pushing down on the brush and then lifting up to the very tip, all in the same stroke. This is a good exercise for control, but it's also used for painting things like leaf shapes!

Cross-hatching

Using the very tip of your brush, create thin and light strokes that cross over one another. This is a pattern you may wish to incorporate into future work, but it's also a great activity for brush control.

Stippling

Like cross-hatching, this technique is useful for both patterns and brush control exercises. Create dots of varying sizes using the very tip of your brush. Add pressure to increase the size of the dots.

DRY ON DRY

Also known as "dry brush effect," this technique happens when we apply a dry brush (minimal water) to dry paper, with color on our brush. This results in a very textured brush stroke. We can use this technique to achieve many different effects. To avoid placing too much water on your page and getting blobs where you don't want them, use a tester piece of paper first to make sure the brush is dry enough. It can be quite difficult to achieve dry brush (often the stroke is a little damper on the first couple of strokes), so a tester piece of paper will help make sure you're putting down the amount of paint and water you really want.

TRY THIS:

Dry brush strokes
Dab off a clean brush onto a paper towel, then dip into any color of your choice. Make some strokes on paper. The more strokes you paint, the drier your brush will get and the more textured your strokes will be. Try this holding the brush at different angles.

Scumbling
This is one of my favorite watercolor techniques. I use it all the time to add texture to the coats of animals and to darken areas without having to go in with a whole new wet layer that might create harsh lines. Dip into the color you want, then dab off onto a paper towel. We want the brush to be very dry. Using the belly of the brush, scratch and rub the bristles over your paper. If using cold press paper, this should create a lovely texture as the bristles will only be touching the peaks of the paper.

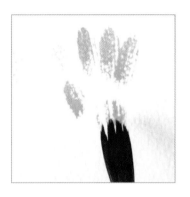

Fan brush effect

I'm a huge fan (pun intended) of using minimal supplies, and we can use our round shaped brush like a fan brush by spreading out the bristles with our fingers! The brush will need to be damp but not wet in order to keep the bristles spread out. Once you've flattened and spread out the bristles, dip it into some color and paint some scratchy strokes.

DRY ON WET

This technique is the opposite of wet on wet, and will allow you to apply color to an existing wet area of your paper with a lot more control. Sorry, leaf blower. It's not your day.

To do this, wipe off as much water as possible onto the inside of your water jar or a paper towel before loading your brush with some pigment. Having a mostly dry brush will mean that it is thirsty and will act like a vacuum. It will suck up some of the excess water on the page, and leave some pigment in its place.

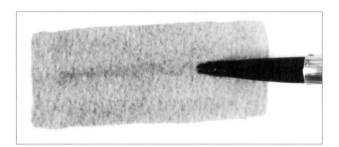

TRY THIS:

Paint a wet area using either plain water or a color. Clean off your brush and dry it off significantly before dipping into any color of your choice. Holding your brush upright, paint a thin line through the wet area on the page. If the paint still explodes outwards, try drying the brush off more next time. If the paint didn't "come out" of the brush at all, you may need a tiny bit more moisture on the brush.

BLENDS AND BLEEDS

Bleeding sounds like a cause for concern in regular life, but in watercolor life, it's dreamy. Bleeds happen when one area of watercolor runs into another, and blends involve multiple colors softly meeting and mixing. This is particularly fun in pattern work, but it can also be super annoying and something you may want to avoid. Either way, it's worth trying out to see how it works!

TRY THIS:
Bubble bleeds
Alternate between painting a circle of water and a circle of paint, allowing each circle to touch the ones beside it right at the last moment. Without manipulating them, allow the circles to bleed into one another. Experiment with different amounts of water on your brush to see areas of color rush into others faster.

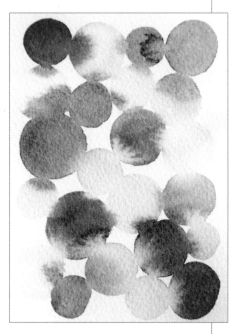

Block blends
Paint a small block of color. Then paint another block of a different color next to it, and allow them to meet at the very last moment. Without manipulating them, let the colors blend into one another. Tip: Avoid complementary colors if you don't want brown. Try two adjacent colors on the wheel, such as blue and yellow or red and blue. Try not to use too much water either, as this will cause the colors to rush into each other rather than softly blending.

Dry into wet

Paint a block of clear water, then pick up a saturated mix of color on your brush and carefully paint it along the bottom edge of the water. Watch it flow into the water and create magic!

Wet into dry

Try the opposite of the above activity. Paint a strip of color (but don't make it too wet), then clean off your brush and fully load it with water, swiping it along the strip of color. Notice the difference in the bleed?

BLOOMS

Blooms (also called backwashes, back runs, or cauliflowers) occur when we add some water to an area of our painting that is ALMOST dry using a fully loaded brush. The leaf blower effect! However, instead of rushing smoothly into an area like in wet on wet, because the area has started to dry, the water and paint we introduce to the page will spread unevenly, creating an interesting effect. Remember: The water and paint will only spread in the bounds of the wet area you've already painted. But if we're careful, we can also use the technique wet on wet, to create soft little dots of white space.

TRY THIS:

Paint some color onto your paper, and wait until it starts to dry and there is just a slight sheen to your page. This means that the paper is still a little bit wet, the perfect time to make a bloom. Use a brush fully loaded with water, and dab it on areas of the almost-dry paint. Try it with varying amounts of water on your brush and see what happens.

GLAZING AND LAYERING

Glazing is layering one color on top of another when the first layer is completely dry. This gives a beautiful, airy effect, showcases the lovely transparency of watercolor, and can alter the two colors where they meet and cross over each other. It's also great for just building depth and color if your previous layers aren't cutting it. It is super important that you wait until the bottom layer is completely dry, or the colors will bleed into each other.

TRY THIS:

Paint some shapes using a relatively diluted mix. Wait until they are completely dry. Then, using some other colors, paint different shapes on top of them, layering them over parts of the original shapes.

FLAT WASHES

A flat wash is a nice, consistent glaze of color in an area of the page. Think of a beautiful clear blue sky. Skies are a common thing to paint with a flat wash. The aim is to get, you guessed it, flat color across the area. We want to avoid harsh edges, or anything funky like blooms and bleeds.

TRY THIS:

Load your brush with color and paint a stroke from left to right (or right to left if you prefer). Reload, and do the same thing underneath the initial stroke, gently touching the first one. Repeat until you've painted an area you're happy with. Try to keep the strokes to a minimum, as the more moisture we introduce to the page, the more likely we are to create an unwanted effect. However, if you reach the end and notice anything strange happening, like one of the corners starting to dry before everything else, clean and dab your brush off, and run the clean, damp brush back and forth over the whole area to smooth it out.

DEALING WITH HARSH LINES

Harsh lines can be one of the most frustrating parts of watercolor, and avoiding them usually comes down to water control. Harsh (or hard) lines are formed when you paint an area like a circle, and the outside (think of it like a crust) dries darker than the inside of the shape. A few things can cause this. Quite often it's due to having too much water within the area, or adding excess water with your brush to an already damp area, which then pushes the pigment to the outer region of the shape. However, it can also be caused by lesser quality paper that doesn't absorb properly, and is affected by humidity and heat. The edges are the first part of a watercolor shape to dry, paint dries faster in warmer temperatures, and we tend to add more water to keep areas damp.

The best way to deal with harsh lines is to avoid them in the first place, but this isn't always as easy as it sounds if you're a beginner! The skill will come with time, as you become more familiar with how much or how little water you need for the technique you're attempting. As you progress, you'll likely invest in better quality paper (if you haven't already), and you'll become faster in general, meaning you won't let an area dry while you do something else like mix a color. A good way to work faster is to have all of your mixes and colors prepared on the palette before you start an area.

What if it's too late, and you already have a harsh line dried on your page? I like to get a brush (generally brushes with stiff bristles work best), make sure it's clean and relatively dry, then gently scrub the hard edge. I make sure to scrub in the direction of the line so I'm not dragging color into the white part of the page, or back into the shape where it can reactivate the rest of the color. I regularly press a paper towel onto the area to soak up any excess water my brush may have added. I also regularly clean off the brush and dab it on the paper towel before going back in to scrub, as it will pick up some of the color as you go. Check out the next section on **Lifting** for more on this.

LIFTING

With a brush and paper towel

Lifting is a great technique, particularly if you need to fix a mistake. If your paint is still a bit wet, you can use a damp brush to "suck up" the paint and water. Wipe your brush on a paper towel and repeat until you've lifted as much as you need to.

You can also use a paper towel to lift paint and water. The paper towel technique is quite effective, so if you only want to lift the color a bit, be very gentle. Heavy pressure can soak up a lot of paint! If I want a softer-looking area, I'll use a wet paper towel (squeezed out) and lift with that, rather than a dry paper towel, which can leave really sharp edges.

Pictured (L-R): Lifting with brush on wet watercolor, with brush on dry watercolor, with dry paper towel on wet watercolor, with damp paper towel on wet watercolor

The staining quality of the color you've used will make a difference, as well as how saturated the color is on the page. Lighter, more watered-down color (like wet on wet) will be easier to remove compared to a heavily saturated, dark color that was painted directly on dry paper.

Lifting isn't only good for fixing mistakes, though. It can be a great way to add soft, fluffy clouds to a blue sky, or to create interest and texture in a piece.

TRY THIS:

Paint an area and allow it to dry. Try to lift the color off using your brush, and dab the excess water away with a paper towel. Paint another area but don't allow this one to dry before trying to lift the color. Use your brush, dry paper towel, damp paper towel, and even a cotton ball for different effects.

SALT

Have you ever seen watercolor paintings with incredible textured detail and wondered how to create the same effect? Salt has entered the chat.

Adding salt to our paintings can create all kinds of wild textures and effects, as the crystals soak up the pigment where they were dropped. How wild it gets depends on the size of the salt granules, the type of paper, the pigments you're painting with, how dark you've painted them, and what stage you add salt to your paintings.

I find that the best results with salt come from sprinkling it on when the paper is starting to dry, and you can still see a sheen across the surface. If the paper is super wet, there is too much water and pigment for the salt to absorb, and if you drop the salt in too late, it doesn't have enough to soak up. I also find that the best results come when you leave the piece to dry on its own, rather than trying to speed it along with a heat gun.

TRY THIS:
Grab some salt from your pantry and add different sized granules into your work at different drying stages to see the results.

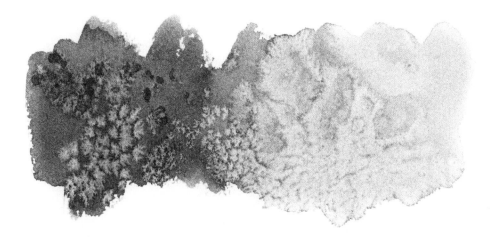

SPRAYING WATER

Before and after color

Don't have any salt? Fear not! You can use water to create texture. We already know that excess water can create blooms, and that's what spraying water onto our work produces: lots of blooms!

One easy method is to paint some color on the page, and while it's wet, spray water onto it. The longer you wait to spray, the more dramatic the effect, as the extra water will push the pigment out to the edges that have started to dry.

TRY THIS:

Clear your workstation of anything you don't want to get wet, including electrical appliances. Paint some color, then spray it with water at different stages of drying and see what effects you can create! You could also lift and tilt the paper to let the color run.

MASKING FLUID

Tape, pen, and liquid

If you want to keep a specific area of your painting completely clean and dry of paint, you can use masking fluid to protect it. Masking fluid is essentially a liquid latex. It comes in a bottle and can be applied with brushes, calligraphy nibs, or ruling pens. It also comes in pens for easy and precise application. You can also use masking tape, painter's tape, or washi tape to block off areas you want to keep clear!

The key to using masking fluid effectively is to apply a very thin layer of it and let it dry completely. When it's time to remove it, wait until the paint on top of it is completely dry, too. Don't rush it to dry with a heat gun, as it can fuse to the paper, and be careful when removing it. A sand eraser can help to loosen an edge of the masking fluid, and you can then gently roll your finger back and forth over it, causing the masking fluid to ball up and start to come off. I find working at it slowly and in small sections is much more effective than trying to stretch and peel large pieces off the paper, as the latter can cause tears. If we tear off the top layer of the paper, it won't behave as it should when we try to paint something on it.

TRY THIS:

Using masking fluid (or tape), cover some bare paper. Next, paint over the top of it and let it air dry completely. Once dry, gently remove the masking, and see your bright, clean paper shining back at you! You can try applying masking fluid in various ways to see how it works best for you: thin strokes, thick strokes, dots, shapes, and anything else you like.

projects

leaves & plants

The great thing about painting leaves and plants is that there are so many variations, and it's easy to find inspiration around your house, your backyard, and out in nature. In this project we'll explore painting leaves with a round brush, which makes it easy to get a variety of strokes and achieve lots of different leaf shapes.

Techniques used: Wet on dry (page 74), blending (page 78)

COLORS USED:

YG , G , B + O = ⬤

Leaves

When it comes to painting leaves with a round brush, we really want to pay attention to two things. First, the angle of our brush. If we hold the brush upright, we will be able to touch just the tip of the brush to the paper and achieve a really thin stroke, which is perfect for the stems (1) and veins of leaves (2). If we adjust that angle and put some pressure on our brush, we can then use the belly of the brush and splay out the bristles, allowing us to effortlessly paint the body of the leaves. We can do this entire process, stem to leaf, without even taking our brush off the page, simply by gently pushing down and releasing pressure on the bristles as we go. (3)

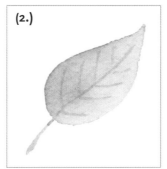

(1.)

(2.)

(3.)

Example of a thin stem, painted by using just the very tip of the brush on paper

Example of a leaf with thin veins painted on using the same technique, the very tip of the brush on paper

Example of a single-stroke leaf, painted in one stroke by changing the angle and pressure on the brush from thin and light, to thick and heavy, back to thin and light

However, sometimes when we use the tip of the brush, we still get a blobby stroke. This indicates we have too much water and pigment on our brush, so not only do we have to pay attention to the angle, but we also have to be careful not to load up our brush too much when painting such a delicate stroke.

Thin stroke vs. blobby stroke

Minimizing the amount of water and pigment on our brush can lead to another issue, though: a broken stroke, or one which isn't smooth and consistent, and allows some of the paper to show through (1). (See Dry Brush on page 76.) It can take some practice to find a balance. In the meantime, you can simply paint the stem first with minimal water and pigment on your brush, then go back and reload to complete the leaf (2). This works perfectly if you want a different colored leaf from the stem, too!

(1.)

Broken stroke leaf

(2.)

Stem and leaf painted separately,
using different colors

TRY THIS:
Practice your brush and water control by painting a variety of different leaf shapes and their stems. You can also wait until the leaf is dry and carefully paint veins over the top for a more detailed look.

Single-stroke leaves
Create these by painting the stem with the very tip of your brush, keeping the brush very upright. Without removing the brush tip from the page, continue the stroke, but this time push down on the brush to splay the bristles out, creating a fatter stroke: your leaf! You can then release the pressure towards the end of the stroke to taper the end of the leaf into a point.

Two-stroke leaves

When painting a two-stroke leaf, we can make the leaf look more rounded than is possible with a one-stroke leaf, and we can also change colors in between strokes to add dimension. To do this, paint one side at a time. Paint a stem, then push the first stroke out to one side as you drag it along, and taper off into a point. Then dip your brush into a slightly different green shade

before completing the second half of the leaf, which you will push out to the opposite side. The aim is to manipulate the bristles on your brush to make the outer sides of each stroke curved, and make them gently touch in the middle and blend together. If you don't like the shape of your leaf after painting two sides, you can go in and correct it manually. Changing shades of green for the second stroke is a fun effect that can give the impression that the leaf is bent in the middle, and one side is shaded. You can also paint the second stroke with just water and let the green of the first stroke flow into it.

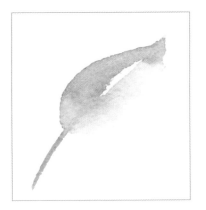

Two-stroke leaves with a gap for the main vein

For a loose and modern effect, paint two sides of your leaf separately as above, but this time don't allow them to touch completely in the middle. This will leave a thin, white gap, which gives a loose impression of a vein.

Multi-stroke leaves with painted veins

Paint your leaf in the desired shape and color. Once it is completely dry, use the very tip of your brush with only a small amount of color and water on it to carefully paint in the veins. You can also switch to a much smaller brush to make this easier. Try to follow the curves of the shape you painted to make it look more realistic.

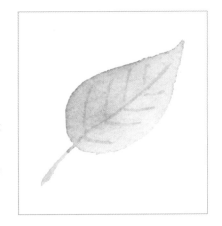

Different shaped leaves, such as short and round, or long and thin

ROUND: Paint a thin stem, then paint a circle that touches it. To make it more interesting, paint the circle in clear water first, then add a touch of color to one side of the leaf and let it fade across, creating a nice gradient.

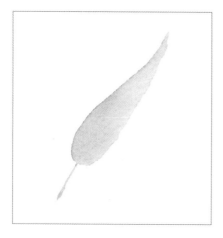

LONG: For a long leaf, paint the stem, then drag your brush out farther with your leaf strokes to make it longer. You may need to reload the brush if your strokes become broken, meaning you've run out of water on your brush. Make it more interesting by using the same technique as the round leaf, painting it with water first then adding color. You can also paint the two sides of the leaf different shades of green.

TIPS:

• Experiment with different shapes, sizes, and colors. Have fun with it! Why can't a leaf be purple?

• It is often easier to complete a leaf shape if you paint the stem (and/ or branch) first. Try bending your stem and branch strokes in different directions instead of just straight lines for a more natural effect.

• The fewer layers you do, the more loose and modern your watercolor style will look. If you're aiming for a more realistic look, don't be afraid to layer up.

plants

Let's step it up a level now and paint some whole plants! We're just going to cover a couple of types because there are so many, so please don't feel limited by the following examples, and if you're a plant lady like me, look around your house for inspiration and have a crack at painting your own.

BUT FIRST, POTS!

We're going to need something to hold our plants, though, right? Of course! Just like plants, pots come in many different shapes and sizes, but let's take a look at two shapes: square and round.

Here's our first lesson in perspective. If we paint our pot completely side-on (1), it won't look like it has depth, so we'll change the angle a little so that our painting doesn't look two-dimensional (2).

(1.)

Example of a two-dimensional
side-on pot

(2.)

Example of a three-dimensional
pot on a slight angle

To paint rounded pots, start by drawing an oval (1) for the opening from which the plant emerges. The oval will give the impression that we are viewing the pot from the side and slightly above. If the opening is just a straight line (2), it looks two-dimensional, and if the top is a perfect circle (3) it looks like we're viewing it from a bird's-eye perspective.

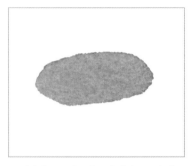

(1) Example of a slightly angled view where some of the dirt in the pot can be seen

(2) Example of a two-dimensional side-on pot, no dirt visible

(3) Example of bird's-eye perspective, all dirt visible

To maintain perspective, we need to make sure the lip of the pot and the bottom of the pot match the curve of the bottom of the oval we drew for the opening (2). If we draw a straight line for the lip or the bottom (1), it loses dimension, and if we don't follow the curve exactly, the pot will look wonky and off-balance.

(1) (2)

Next we join up the opening, lip, and bottom of the pot where the dotted lines appear in example (2) above.

We can follow this process to create a square pot. A square pot is a little easier, as we're using straight lines instead of curves.

Above is an example of how to construct your square pot sketch. Make sure to keep lines on opposite sides of the pot parallel to each other. The lines at the top of the lip, bottom of the lip, and bottom of the pot should all be on the same angle. Likewise, make sure the top of the lip, bottom of the lip, and bottom of the pot on the right side are parallel to each other.

Example of a painted and shaded square three-dimensional pot. Note all of the parallel lines on each side.

Before I put color down, I decide which side my light source will come from. I tend to choose top left. Choosing a light source (think of the sun or a light bulb) tells us which areas of the pot (and plant) to highlight and shade for a more realistic look. It can also help us figure out where to place a shadow on the ground.

In the sketch on the left, the light source is coming from the TOP and LEFT, so the shadow goes on the opposite side, the BOTTOM and RIGHT. Anything along the top and the left should be lighter, because the light source (in this example, the sun) is hitting it and making it brighter.

Once you have your outline sketched and have decided where the light is coming from, you can paint some of the pot. You can also leave this step until after you've painted your plant. Either way, just remember to only color in the lip and sides of the pot before you paint the plant, as the opening will have the plant and dirt in it. You can go back later to fill them in once the plant has been added, or just leave painting the whole pot until last.

Painting a pot before the plant, leaving the center where the dirt and plant will be, and far lip blank so that the plant can be painted in.

Example of non-shaded vs shaded pot. Either works, depending on the effect you're going for. For a more modern and illustrative look, you can leave the pot (and plant) unshaded. For a more realistic and three-dimensional look, add a darker shade of the color you're painting with to the side you have identified as being in the shade, which in this example is the BOTTOM and RIGHT.

TIPS:

• Not keen on pots? All good! There's no reason you can't paint plants coming directly out of the ground.

• Want to dress it up? Go for it! Add color and designs to your pot for extra pizzazz.

• Want to get wild? Forget green! Paint your leaves and plants all sorts of crazy colors for a fun and abstract look.

• Prefer a looser, more modern effect? Instead of going for the dimensional pot look, paint them side-on and flat for a more two-dimensional, illustrative look.

CACTI

When I think plants, I think . . . "what am I least likely to kill?"
And for me, that's cacti! I'm also deeply obsessed with Palm Springs,
and cacti instantly remind me of that desert heaven.

Step 1: Paint the body of the cactus with
a green of your choice, adding more saturated
color (or a darker shade) to the side
you've chosen to be in the shade
(opposite your light source).

Step 2: Add some extra "arms" to the
cactus, making them as large as you choose.
Try to change up the positioning each time
so it doesn't look too manufactured.

Step 3: Once dry, add some spines
using white gouache. Add a pot and
you're done!

TIP: You can also use masking fluid to create
the spines. Sketch your entire cactus shape
first to make sure you get them in the right
place. (See page 86 for masking fluid.)

SMALL HOUSE PLANT

With just some simple teardrop shapes and stems, we can create some really cute house plants!

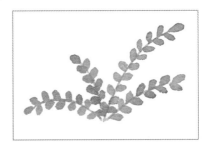

Step 1: Paint a stem, bending off to one side.

Step 2: Starting at the end of the stem, paint a teardrop shape with the thin part touching the stem, and the widest part as the end of the leaf.

Step 3: Repeat this down the stem.

Step 4: Create more stems and leaves until your plant is looking nice and full.

Step 5 (optional): Add a pot underneath.

PALM

Another simple but beautiful plant to try is a palm.

Step 1: Paint a stem, bending off to one side.

Step 2: Starting at the end of the stem, paint a long single-stroke leaf emerging from the stem and finishing in a thin tip.

Step 3: Repeat this down the stem, occasionally changing the shape and direction of the leaves.

Step 4: Create more stems and leaves until your palm is looking nice and full.

Step 5 (optional): Add a pot underneath.

flowers
and Wreaths

Arguably the most popular thing people want to paint with watercolor is florals. So let's dive in and learn to create the perfect blooms for our leaves and plants!

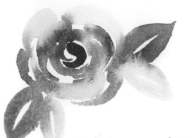

Techniques used: Wet on dry (page 74), wet on wet (page 73), blending (page 78)

COLORS USED:

R , YG , G

Step 1: Create a mixture on your palette of a red or pink color, and load your brush with concentrated pigment. We want the center of our rose to be saturated.

Step 2: Holding your brush vertically, paint a curve. Paint another curve next to it, facing opposite and interlocking with your first curve. These are the beginnings of our petals. They're tightly bound in the center, and will slowly expand out as though the rose is opening up.

Step 3: Rinse a bit of color off your brush (it doesn't have to be clean) and repeat Step 2, interlocking more curved shapes with the ones you painted previously, and allowing the saturated paint to bleed into the new petals.

Step 4: Reload your brush with more pigment, and repeat the above steps. Alternate between a couple of saturated petals and a couple of watered down petals. If your rose is looking too pale, you can always drop some more color into a damp area that you want more saturated. I also like to vary the thickness of the stroke from beginning to end to add interest.

Step 5: Time to add some leaves! You can do this while the rose is still wet, or you can wait for it to dry. Head back to page 89 for a guide to painting leaves. Keep your rose looking light and flowy by painting one leaf with saturated color, and one next to it with mostly water, allowing them to blend into one another. I also like to change up the shade of green for each leafy bunch.

TIPS:

- We used a bird's-eye perspective in the example above. To create the impression that you're looking at a rose side-on, you can still paint it in a similar way, but don't space the curved petals evenly around the rose. Instead, concentrate the curved shapes on one side of the rose, which will make the tightly-bound center of the rose look like it is facing away.

- Experiment with different colors, sizes, petal shapes, and saturation levels.

anemone

Techniques used: Wet on dry (page 74), wet on wet (page 73), blending (page 78)

COLORS USED:

G , B + O = ⬤

Step 1: Mix up an indigo or blue-gray using primary blue and a little bit of orange, and load your brush with a very diluted version of the color. Begin painting five or six petals. You can paint them all in at once without drying them in between.

Step 2: While the petals are still wet, load your brush with a saturated version of the color you mixed up, and dab it in the center of the anemone, letting it gently soak outwards. Allow to dry.

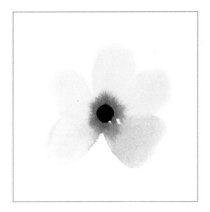
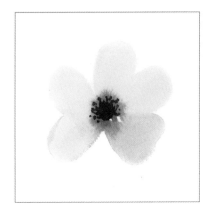

Step 3: On a dry layer, paint a dark circle where you'd like the center of your flower to be, over the soft color we dabbed in before it dried. Using the same saturated color, create lines coming up from the center, and dots all around the circle. Allow to dry.

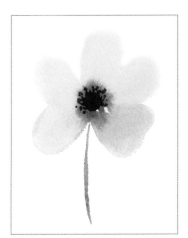
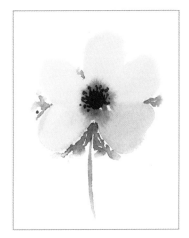

Step 4: Time to add a stem and leaves! Hold your brush vertically to create a thin stem. Around the base and sides of the flower, add some jagged-looking leaves close to the petals.

TIPS:

- Just like with the rose, experiment with different perspectives. By painting only half of the center of the flower and making some petals larger than others, we can make the flower look tilted away.

- Experiment with different colors, sizes, petal shapes, and saturation levels.

Lavender

Techniques used: Wet on dry (page 74), wet on wet (page 73), blending (page 78)

Colors used:

Step 1: Mix up a green color with primary yellow and primary blue, and load your brush. Paint two thin vertical lines for the stems. Make them quite long, and don't worry about them not being perfectly straight. It looks more natural if there are little wobbles and bends.

Step 2: Mix up a violet color with primary blue and primary red, and at the top of your green stem, start dabbing your brush onto the paper.

Step 3: Carry this motion down the stem, and every now and then rinse your brush off, paint a few dabs with just water, then reload it with purple. Make sure these petals are just touching each other, so that they gently bleed into one another. Try to make the top of the lavender sprig a little pointed, widening it slightly as you work your way down the stem.

Step 4: Once you've finished with the petals, rinse off your brush and reload it with green. Paint some long one-stroke leaves on the bottom part of the stem.

Step 5: Repeat as many times as necessary. Create a whole field of lavender if you like!

TIPS:

- When creating lots of lavender flowers next to each other, try to vary the lengths and directions of the stems to create interest. Tilt some over, make some shorter and some longer, and paint more flowers on one stem than others.

- To create a bouquet of lavender flowers, have the stems curve inward, touching at some point where they would be tied together. Feel free to add a little bow, too!

wreaths

Now that we've learned how to paint leaves and a few flowers,
let's chuck them all together for a wreath.

Tips to create a wreath:

- Draw a circle in pencil so you keep the shape really uniform. I like to use the inside of a roll of masking tape, or a can.

- Make sure the circle isn't too close to the paper edge, or else you won't have enough space to fit leaves and flowers on the outer edge of the circle.

- If you want to paint a wreath of leaves only, it's a good idea to mix up more than one shade of green before you start. Just as with the rose and lavender, try to alternate between a saturated leaf and a watery leaf, letting them flow into each other. It prevents the wreath from looking too "heavy" and showcases that yummy watercolor translucency.

- For leaves only, I like to work clockwise around the wreath. It's easier if you have your paper taped to a board you can rotate (or not taped down at all, if your paper is thick enough that it won't buckle) to keep the leaves pointing in the same direction and a similar shape.

- With a leaf wreath, you can choose to paint the circular "stem" first all at once, or paint it section by section as you're adding the leaves.

- When painting flowers, I prefer to add the circular "stem" bit by bit, in case I want to paint a flower over it. Otherwise, the pre-painted stem would be visible through the flowers.

- When painting flowers in a wreath, try to plan out the positioning beforehand so that it ends up balanced. On the left, you'll see I've got

the roses and anemone opposite each other, but I've painted two roses and one anemone so that there isn't too much symmetry. This is because I've painted two sprigs of lavender opposite each other, between the roses and anemone. Balance is important, but symmetry can sometimes be distracting rather than pleasing to the eye.

- If you feel like you need to fill some space, add in some nondescript blossoms or leaves. I've added some small blue flowers below, and some dots of yellow blossom.

feathers

Painting feathers is a little like painting leaves. Like the stem, feathers have a *quill*; like the middle vein, they have a *rachis*; and like the blade of the leaf, they have a *vane*. Feathers also come in so many shapes, sizes, and colors, just like leaves!

I approach painting feathers just like leaves. Before I put brush to paper, I decide whether I will attempt a more realistic style and paint in the center of the feather, or go for a more modern look and paint around the center, leaving a white gap in the middle. I also think about the shape of the feather, and whether I want one color or a combination. Feel free to sketch an outline shape, too.

Techniques used: Wet on dry (page 74), wet on wet (page 73), blending (page 78)

COLORS USED:

Y + R + B = BL B + O = ⬤

neutral feather

Step 1: Load your brush with a color of your choice and dab off any excess water so that your first stroke isn't blobby. Holding your brush upright, slowly paint a line on the page heading away from yourself, with the end tapering off thinner. This will be the quill and the center of the feather.

Step 2: Next, load your brush with another color of your choice. I'll be using black, created by mixing my three primary colors. You can use the same color as the quill if you like. Starting at the top of the feather, begin to paint in your shape. I like to paint a block of color, then rinse my brush off and paint a block of water connecting to it, then load my brush with more color and paint under the block of water.

The example to the right shows the separate "blocks." Connect each piece while they are still wet and let them blend into each other. This keeps the feather looking light and airy, as opposed to heavy and very saturated with solid color. I like to leave some gaps between sections as well as along the center, for an interesting effect. You can make the edges as rough or as smooth as you like—feathers can be either neat or ruffled. Remember to leave space for a quill, so don't take color all the way to the bottom of your center line.

Step 3: Once you've painted the bulk of the feather, using a watered-down color, add the little "fluffy bits" at the base of the feather where it meets the quill.

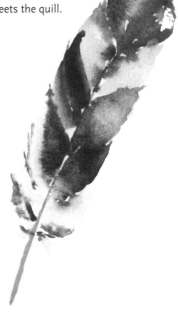

Step 4: While the feather is still wet, you can also go back and add some extra color, or water to create blooms. You can also add little lines and dots in the wet areas, which will softly blend out to create patterns. I like to add some extra color down the center. You can also do this on a dry layer if you'd prefer the details to look more crisp.

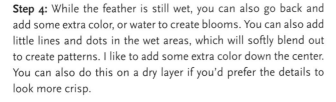

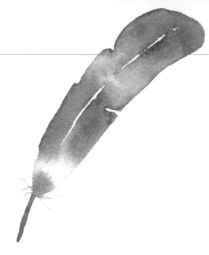

TRY THIS:

After you've tried the first feather, follow the steps on the previous page again, but only paint the quill (the part that pokes out of the bottom of the feather), and leave the center of the feather blank. From Step 2 onward, paint your feather in and leave a gap in the center to give the impression of the middle vein of the feather (the rachis). To make it easier to know where the center is if you're not painting it, draw it with a pencil, then erase it once your painting is dry.

TIPS:

- Experiment with curving the quill and center of the feather in different directions, and painting them with different intensities of color. Remember to follow the shape when painting the rest of the feather. This will help add movement, realism, and perspective, making the feather look like it is bending either inward or outward.

- Try painting feathers of different shapes. Some long and squared off, some short and fluffy. The sky's the limit!

- Look for color and pattern inspiration online and in nature.

- Don't be afraid to try something bold! Your watercolor feathers can be whatever color and pattern you want them to be. You can also try painting the quill a totally different color from your feather.

- Add blooms into your feather by loading your brush with water and touching it to your painted feather. This will push the colors out to the side and create fun textures.

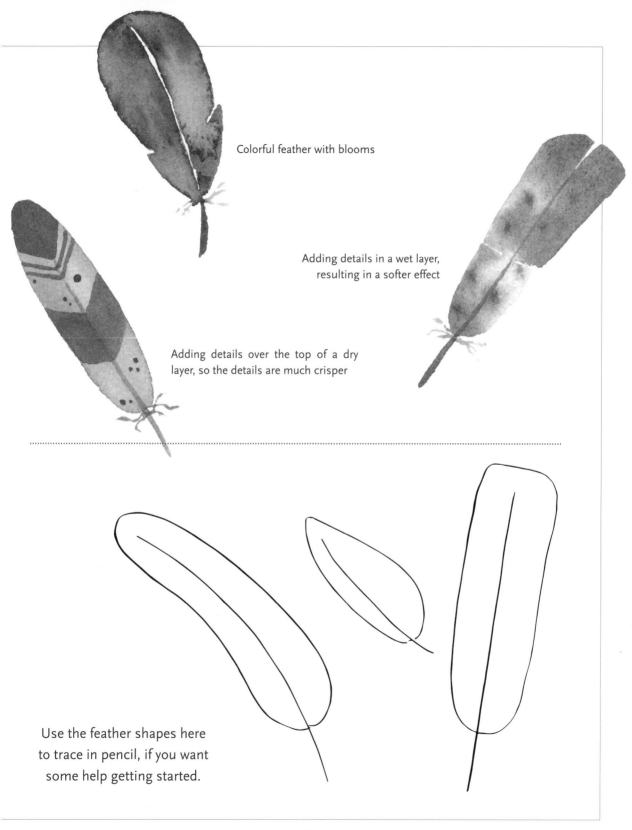

Colorful feather with blooms

Adding details in a wet layer,
resulting in a softer effect

Adding details over the top of a dry
layer, so the details are much crisper

Use the feather shapes here
to trace in pencil, if you want
some help getting started.

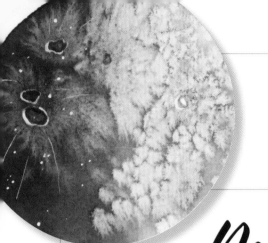

moons

Painting moons is a great way to try out some fun watercolor techniques. We can stay true to Earth's moon, or we can create something a little more interesting.

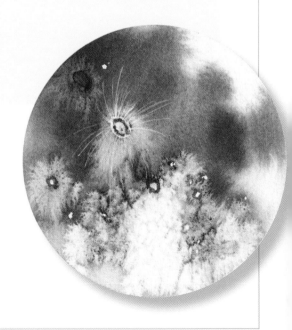

abstract moon

Techniques used: Wet on wet (see page 73), wet on dry (see page 74), blending (see page 78), lifting (see page 83), salt (see page 84)

Colors used:

 V , W

Step 1: Draw or trace a circle for the outline.

Step 2: Fill in your circle with just clean water.

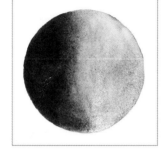

Step 3: Choose a color and start dropping it in. You can select any color palette you like. This one is abstract, after all.

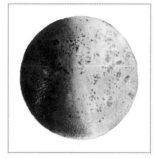

Step 4: Before you let your layer dry, sprinkle some salt on for a fun effect. The salt will soak up the water around it and make an interesting speckled look. Make sure the paper has started to dry before you do this, as if there's too much water on the page it won't work as well. You can also use your brush to lift some color off in certain areas, or drop plain water in with your brush to create some blooms.

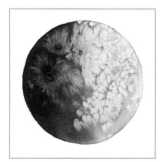

Step 5: When that layer is dry, you can repeat Step 4 if you want to. You could try using a different color or even a different type of salt if you have it.

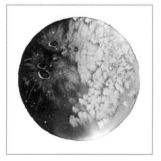

Step 6: On your dry painting, add some dots and lines using a white gel pen or white gouache.

realistic moon

Techniques used: Wet on wet (see page 73), wet on dry (see page 74), blending (see page 78), lifting (see page 83), salt (see page 84)

Colors used:

Repeat **Step 1** and **Step 2** of the **Abstract Moon** (see page 113).

Step 3: This time we're going to use gray. You can create this by mixing the three primary colors together at the same time to create black, then watering it down to get gray. Or if you have a pre-made black or gray color already, you can use that instead. Add a light wash of gray over the whole moon.

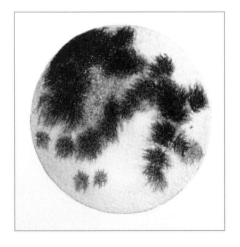

Step 4: While the first layer is still wet, load your brush with some saturated gray and dab it on around 1/3 to 1/2 of the moon. Use your brush to drop the color in, and don't be afraid to let it spread and bloom! We want it to look patchy, not smooth.

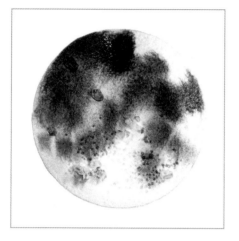

Step 5: While the first layer is still wet, grab your salt and drop it in a couple of areas in small clumps rather than sprinkling it all over the whole moon. This will create some craters.

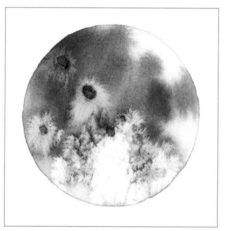 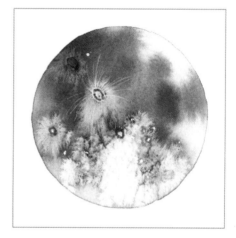

Step 6: Once your moon has dried, use a white gel pen or white gouache to add some dots and lines to your moon to create some texture. Create some impact lines coming out from the big crater.

TRY THIS:

• Who said your moon has to be round? Experiment with waxing and waning shapes for interest.

• For an even more realistic effect, shade one side of your moon with a darker gray (or whatever color you choose to paint your moon).

galaxies

Galaxies are such an addictive type of watercolor painting! You can paint a galaxy in almost any shape, using the same method.

Techniques used: Wet on wet (see page 73), blending (see page 78), wet on dry (see page 74)

Colors used:

$$\text{RV} , \text{V} , \text{B} , \text{W} ,$$

$$\text{Y} + \text{R} + \text{B} = \text{BL}$$

Step 1: Decide on a shape. The universe may be infinite, but we need boundaries. If you want a circle, use a compass or trace around a jar or can. For a square, bust out your ruler. Use the shapes above for inspiration.

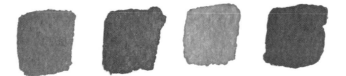

Step 2: Decide on a color palette. I personally think that analogous color schemes work best for galaxies (colors next to each other on the color wheel; see page 62) and I have a strong preference for pinks, purples, and blues. Whichever color combo you decide on, try to have a very dark color in the mix, like indigo, Payne's gray, or black. Without a dark color, it will be hard to build that dreamy space dimension on the outer edges.

Step 3: Using your dark color, start to paint the outer boundary of your galaxy. The trick is not to let the dark paint edges dry or they'll create harsh lines, so while you keep working your way around the boundary, use a clean wet brush to dampen the edges of the dark paint in the center as you go.

Step 4: Once you've successfully darkened the outer boundary of your galaxy, use a clean, wet brush to drop a couple of blooms into the center area for a fun effect. It doesn't matter if a bit of color travels into the center, but to get the best nebula/galactic explosion effect, it's ideal to leave the center of the galaxy quite white and bright. Creating blooms with your brush will also help move some color out if you placed too much in the middle of your galaxy. Once you become more comfortable with water control, you can add more colors on your first galaxy layer. But to keep it simple, make your first layer just the outer dark edge, then dry it.

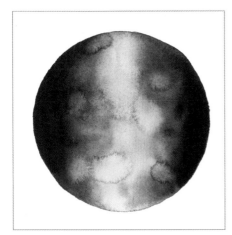

Step 5: Create a new layer using just water, and start to add some of your other colors into your galaxy. If the paper is too wet, you will lose control of the placement, so either apply a thin layer of water, or wait for it to absorb a little bit into the paper. You can also use this layer to darken up the very edge of your boundary if it needs it. Try to leave white space in the center.

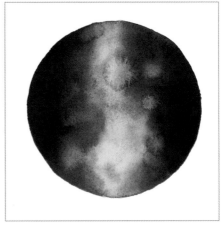

Step 6: Once this layer dries, repeat the steps above to build dimension. This can take a couple of layers, and quite often my subsequent layers will just involve wetting down the whole piece and adding a dark color to the edges to create dimension.

Step 7: If you're looking at your galaxy thinking "yikes," don't worry! It always looks better with stars, and that's what's next. There are a couple of ways to add stars. You can heavily load a brush and hold it over the painting while tapping the handle with another brush or your finger, you can flick white paint onto the paper with a brush or toothbrush and your finger, or you can paint them all in by hand. I like a combination of all three!

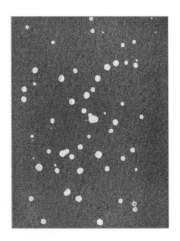

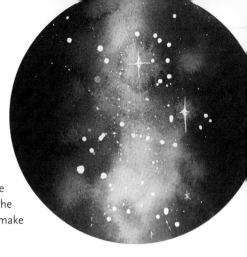

- First I load a brush with white gouache and tap the handle while moving it around my painting. This will splatter white paint down, and moving it around will prevent any giant puddles from happening and ensure an even spread.

- Then I get a brush (a flat top brush or old toothbrush works better than a round brush, but use what you have), load it with white gouache but dab off excess water, and use my finger to pull back the bristles and "spray" my painting with white. I like how splatters make bigger stars and spraying makes smaller ones.

- Finally, I then use a small detail brush to add in any extra stars by hand, and to add details like shooting stars or sparkling stars.

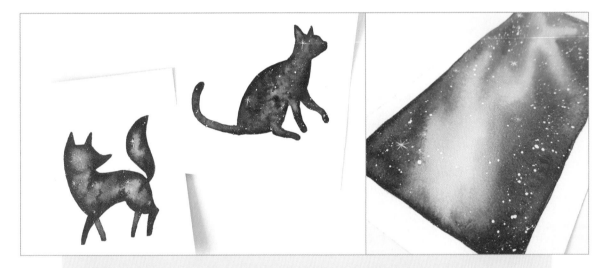

TIPS:

- Before adding stars to your final painting, try the different star techniques on a scrap piece of dark paper.

- Make sure your workspace is protected, or add the stars to your painting outside. You'll be amazed just how far flicked paint can travel!

- Pick an interesting shape as your boundary. My favorite is painting galaxies in the shapes of animals.

- Try different color schemes for interesting effects.

- Experiment with different amounts of layers.

the sky

There's no doubt about it, watercolor skies can look really intimidating to paint. But here's a little secret for you: It's usually the foreground that makes a sky painting look good. The sky itself can some-times just look like abstract blobs and streaks. This means we can let loose and have some fun without stress-ing too much about perfecting the sky. After all, the sky looks different every day, so embrace the endless possibilities!

Let's not understate the importance of clouds, though. Without them, the sky is just a block, blobs, or streaks of color. It can look abstract without clouds for context. Clouds can really set the mood, so let's learn how to paint them!

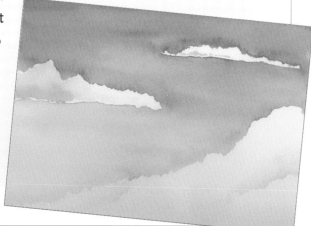

Cloud Technique #1

NEGATIVE PAINTING

Techniques used: Wet on wet (see page 73), wet on dry (see page 74), lifting (see page 83)

Colors used:

The first way we can paint clouds is to . . . not paint them! Instead, we can paint the sky around them, and then add some details later like shadows for depth.

Step 1: Sketch some cloud shapes with pencil. I know you know what clouds look like, but negative painting can make it a lot harder to get your shapes right.

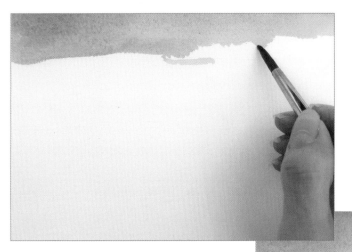

Step 2: Using a nice bright blue color, start to paint your sky, avoiding the cloud shapes. Carefully paint around them, trying not to distort the shapes from the sketch you made.

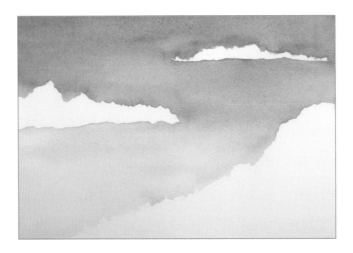

Step 3: Try to make the top half of the sky richer in blue, and use more water for the bottom half of the sky. (The daytime sky normally looks darker higher up, so this gives the illusion of depth.)

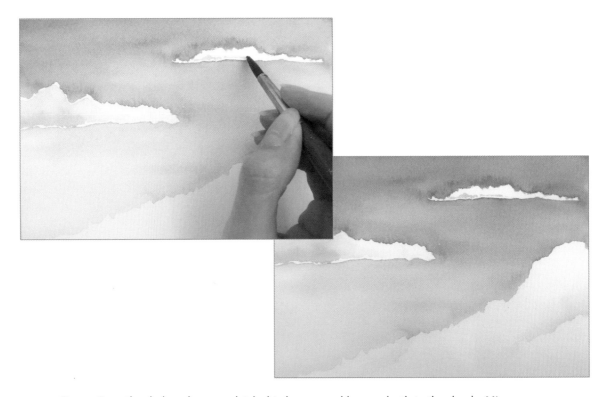

Step 4: Once the sky layer has completely dried, we can add some depth to the clouds. Mix a gray on your palette using the same blue as the sky plus a little bit of orange, and water it down quite a bit. Carefully paint some gray around the bottoms of your clouds. This helps give them depth and weight, and makes the tops look super fluffy.

Cloud Technique #2

LIFTING

This time we're going to extract our clouds from the sky by lifting them out of a wet layer. (See page 83 for more on lifting.)

Step 1: Choose your color palette and paint over the whole area of your paper. Because we're going for a softer look, this can be more easily done if you wet the whole page with water first, then add your color in a gradient from dark at the top to lighter at the bottom. I'm using a slightly muted blue. (See page 59 for tips on muting your colors.)

Step 2: Wash off your brush so it no longer has color on it, and dab it on your paper towel to remove the moisture. While the paper is still wet, lift color off the page using your brush, to form the clouds.

TIP: If you find the process of using your brush a bit tedious, grab some paper towel instead. You can use a dry paper towel if you want to create harsher edges. But if you want to keep your clouds nice and fluffy, dip your paper towel in water first, then squeeze as much water as you can back into the jar. Use the paper towel to lift your clouds. It will still be absorbent enough to soak up the color, but won't leave hard lines like a dry piece.

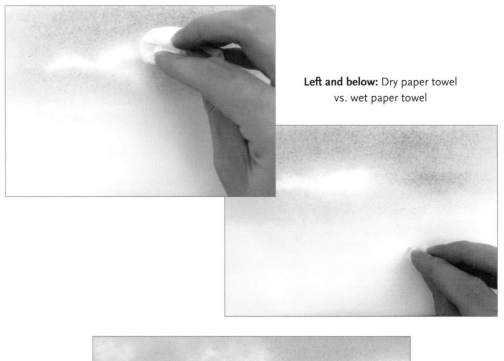

Left and below: Dry paper towel vs. wet paper towel

Step 3: Continue to refine your cloud shapes while your first sky layer is still wet. Keep in mind that if your sky will air dry, there is a chance the paint will soak back into the places you've lifted it from. Watercolor goes where water is. This is why I like using a heat gun to dry my paper; it locks in how I want it to look. If you don't have one, lift a little more paint than you think you'll need to.

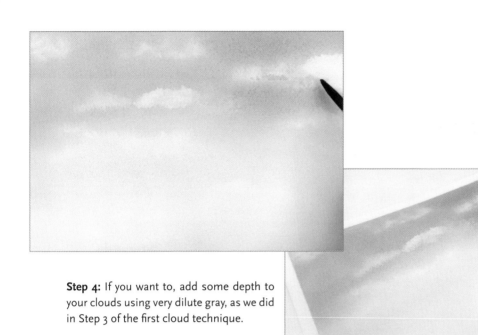

Step 4: If you want to, add some depth to your clouds using very dilute gray, as we did in Step 3 of the first cloud technique.

TIPS:

- Change up your color palette to set the mood. Want a stormy sky? Use lots of grays. Want a summery sunset? Use blues leading into purples, pinks, oranges, and yellows.

- Try incorporating both cloud techniques into your sky to create interest.

- Always keep in mind your end game. Do you need to paint parts of a landscape that are light in color after the sky? Don't take your sky all the way to the base of your page.

- Just like a galaxy always looks better with stars, don't forget: The sky always looks better with a foreground.

Ready to turn it up a notch and create a dreamy sunset landscape?
See you in the next project!

sunset landscapes

Now that we know how to paint clouds, it's time to create a summery island sunset!

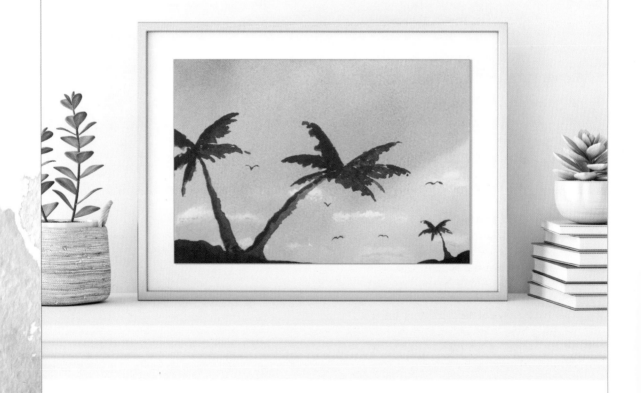

the sky

Techniques used: Wet on wet (see page 73), wet on dry (see page 74), blending (see page 78), lifting (see page 83)

Colors used: Y , O , R , RV , V , B

Step 1: We will be working wet on wet and lifting our clouds out in this painting, so be sure to tape your paper down to your working surface to prevent buckling. The paper will still warp a little when wet, but this will help it stay flat once it dries.

Step 2: Prepare your colors before you start painting, so your page won't begin to dry before you're ready. Create mixes of blues, purples, pinks, oranges, and yellows.

Step 3: Wet down the whole page with water first to give yourself extra time to work with the colors.

Step 4: Starting in the top left corner, add some blue. I like to paint mine on a diagonal so that it looks like the sun is setting on the opposite side, in the bottom right corner. Use a back- and- forth "windshield wiper" motion as you paint, and take each stroke beyond the edge of the paper (onto the tape is fine). If we start or finish these strokes in the middle of the paper, it can cause a bloom (explosion of paint in all directions).

Step 5: Add some purple next to the blue. Then some pink next to the purple. Then orange, then yellow in the bottom right corner. This color order is important. Blue and orange are complementary colors, as are purple and yellow. They'll turn to mud if they touch. Make sure you keep them in this order to avoid that. Don't be afraid to go back over the areas with more color on your brush if they're looking pale. Colors do fade when a painting dries and the water evaporates. Just remember that windshield wiper motion, and start and end each stroke beyond the edge of the paper.

Step 6: Your colors may be looking "blocky" at this stage, so let's blend! I like to take a clean, damp brush (not loaded with water) from one diagonal down to the other, still using that windshield wiper motion. Start from the blue corner and swipe your brush back and forth on a diagonal all the way until you get to the yellow, making sure each stroke goes beyond the paper and onto the tape (or surface you're working on) so no blooms happen. If you feel like your brush is bringing too much color down from the blue corner, clean off your brush before working from pink to yellow. This will prevent any muddiness.

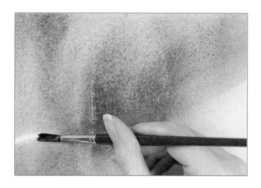 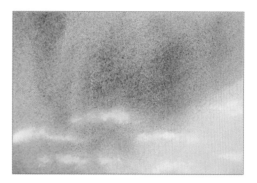

Step 7: Once you're happy with the vibrancy of your colors and the blend, use your brush or a damp paper towel to lift some clouds off. (See page 124 for this technique.) Try to keep the clouds really long and skinny, and fairly low to the horizon.

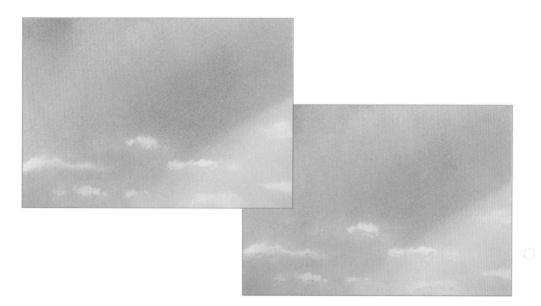

Step 8: Once the sky is completely dry, we can add a very subtle shadow to the base of the clouds. For the clouds close to the right side (where our sun is setting), use yellows and oranges at the base of the clouds, as though the sun is reflecting off them. For clouds farther away from the sun, use pinks and purples to shade instead.

Tip: If your sky colors have dried much paler than you anticipated and you want your painting to be more colorful, don't be afraid to repeat Steps 3-7 and give it another layer. Just remember to lift paint off the same areas where you painted the clouds in the first layer, so they stay white.

the foreground

Now to add the infamous foreground!

Colors used:

$$Y + R + B = BL$$

Step 1: Prepare black paint on your palette. You're welcome to use a pre-made black from a tube or pan. This will ensure good coverage and means you won't run out, but it can sometimes look a bit flat and take the life out of a painting. For a more dynamic black, mix your own using all three primary colors (refer to Mixing Black on page 58). Be sure to mix enough so that you don't run out!

Step 2: Paint two islands using black, one on the bottom left and one on the bottom right. I like to make one bigger and longer than the other, just so the symmetry doesn't distract the viewer. We can then use the larger island to create perspective and distance, and make it look closer to us than the small island.

Step 3: Paint some trunks of palm trees. Don't forget to make the ones on the left island much bigger than the right, so they look closer to us. Curve them in different directions, and change up the size and shape to create interest. I also like to make them look a bit rough, rather than perfectly smooth trunks.

Step 4: Paint some branches and palm leaves to finish off the trees. Vary the size and shape of the leaves, and remember that gravity exists, so it's unlikely that branches and leaves would be pointing straight up into the sky. It's up to you whether you paint the branch positions first and then add the leaves, or just paint one whole completed branch at a time. If your black is a little watered down, you can also make the left sides of the trunks and branches extra dark black to create shadows and dimension. We put the shadows on the left, as the sun (light source) is on the right.

Step 5: Add a couple of loose "m" shapes with the very tip of your brush for some soaring birds in the distance. You want black on your brush but hardly any water, to avoid making some very blobby birdies. And you're done!

TIPS:

• Try to avoid creating mirror images of your landscapes by changing the size and positioning of the islands and trees. Paint the birds at different heights, and flying in different directions.

• If you choose to mix your black, you may find that your color looks a little watery. If it dries too light, feel free to go in with another layer.

foggy forest

Techniques used: Wet on wet (see page 73), wet on dry (see page 74), lifting (see page 83)

Colors used:

What makes watercolor so challenging for many beginners is that we're often not painting an object, but actually manipulating the paint or even removing it to create an effect.

Fog, for instance: We don't paint this over our work. Watercolor is transparent, so it wouldn't cover up what's under it, which is how fog works in real life.

Instead, to create the effect of fog with watercolor, we actually have to remove part of the painting that we want to appear foggy. We can do this with lifting. (See page 83.)

In this painting, we're going to make the floor of a forest look like it has some fog lingering around. We need to work back to front. To make the fog effect look believable, the objects in the background need to be diluted and smaller, becoming clearer and more saturated the closer to the viewer they get, just like with real fog.

Step 1: Mix up a nice, dirty, dark green color using primary blue and yellow, then adding a little bit of primary red to neutralize it. Wet down the whole page with water, then load your brush with the color and start to dab it into the corners of the page. Slowly drag a little bit of color around to the edges using your brush. Let dry.

Step 2: On a new layer, start painting some tree trunks using a very diluted version of the color. These will be in the distance, and we should make them thin so that they look farther away. Make the strokes a bit wobbly and jagged. Hold your brush vertically and gently drag it from the center of the trunk outwards to create some creepy branches. Try not to paint them symmetrically—i.e., one on each side of the same trunk at the same height. Let dry.

Step 3: On a new layer, repeat Step 2, but use a more saturated version of the color. Once you've painted two to three light-colored trunks, while they are still wet, grab some paper towel and gently dab it on the bottoms of the tree trunks. This will make the forest floor look even foggier. Add some strokes for grass and be sure to dab your paper towel on those too.

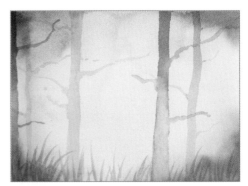

Step 4: Once your next layer of trees has totally dried, repeat the above steps, but this time make the tree trunks and grass even darker and thicker than the first two layers. Again, use a paper towel to dab some color off the bottoms of the trunks.

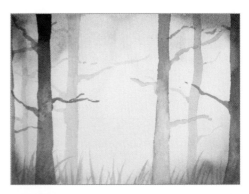

Step 5: If you've still got space, add another one to two trees, repeating the above steps, but this time, use a really saturated version of the color. I ran out of my dark green mix, so this time made the mixture a bit more blue for visual interest. Again, use a paper towel to dab some color off the bottoms of the trunks.

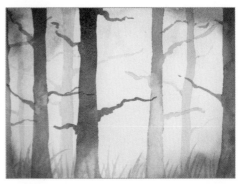

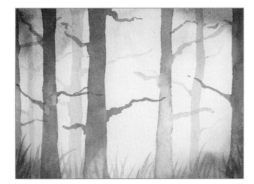

Step 6: Once the foreground trees have dried, we can add a few little details that would only be clear if they were close to us, like some long blades of grass. I like to paint mine on the edges of the painting, so it looks like they are fading into the center where we painted them lighter on a previous layer.

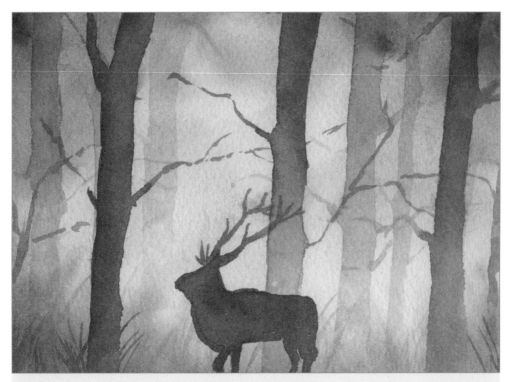

TIPS:

- Once you're confident with the technique, you can try adding in more than one color. For example, brown for the trunks and green for the foliage.

- Try adding in some leaves on your branches, remembering to keep them the same saturation as the tree you're painting them on.

- Try adding in an animal silhouette for extra forest-y goodness.

whale

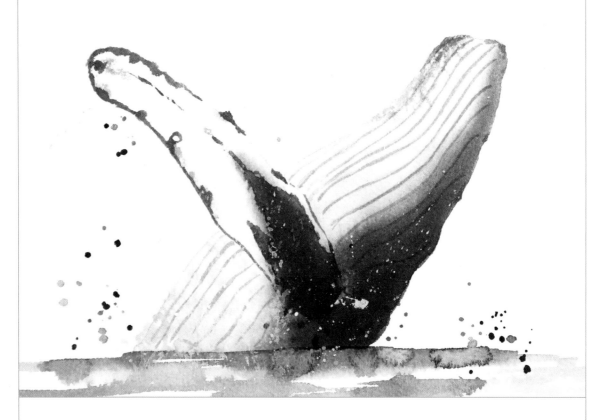

My personal favorite subject to paint with watercolor is . . . animals! There are lots of reasons why, but I particularly love that you can achieve difficult-looking effects with watercolor animals that actually aren't very difficult and don't take a long time.

Dry brushing techniques are among my favorites to use on animals. We can create a fur-like texture, a rough skin texture, or even feathers just by "scrubbing" or brushing the bristles in certain ways on the surface of our paper. We'll create that yummy texture below on this whale.

Techniques used: Wet on dry (see page 74), wet on wet (see page 73), dry on wet (see page 77), blending (see page 78), blooms (see page 80)

Colors used:

Step 1: Trace or copy the outline of the whale. So far, we've been free-handing a lot, but when it comes to animals, I recommend using an outline so we can keep things in proportion.

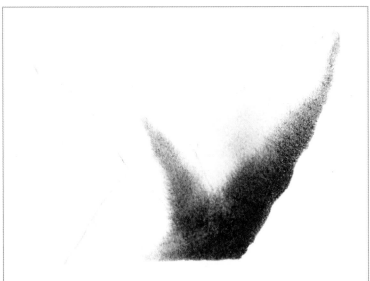

Step 2: Mix up a blue-gray color by adding a bit of orange (red and yellow) to your primary blue. I like keeping a variety of colors on hand, from blue to gray, so that I can change the color in certain areas as well as create visual interest.

Step 3: Using a clean, wet brush, fill the whole whale body in with water. We want to add a very light tinge of color to the fin and the belly, but try not to get much color there—just enough that it'll stand out on the white paper. Then, while the layer is still wet, drop some saturated color along the right side and bottom of the whale. Allow to dry.

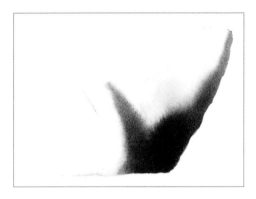

Step 4 (optional): If your whale has dried very light, you can repeat Step 3 to deepen the blue-grays.

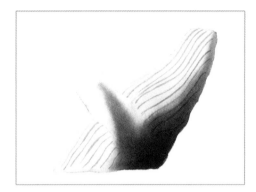

Step 5: On a new dry layer, we can start adding some detail. Take some watered-down blue-gray on your brush, and draw a few thin lines with the tip of your brush from the end of the whale's face to its fin, continuing on from under the fin to the bottom of the whale. It doesn't matter if some of these are wobbly or vary in thickness; it helps add visual interest. Hold your brush vertically and use very little pressure to get the thinnest stroke possible.

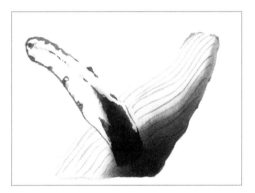

Step 6: Using a saturated blue-gray on a dry brush, gently scrub some detail on the fin of the whale. I like to maintain a loose grip on my brush when I do this so that the strokes don't look deliberate. We want to concentrate the texture around the tip and sides of the fin, as well as a thick area around the base of the fin where we applied saturated color on the earlier wet layer. For the base of the fin, we need a bit more water on the brush to cover the larger area, and once you reach the area where the fin connects to the body, use only water to fade the color into the body.

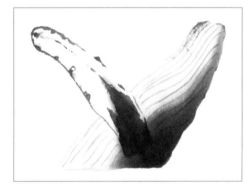

Step 7: Take a separate puddle of your blue-gray color, and add more orange to it, so that it becomes brown. Use this color and the technique in Step 6 to add some texture to the chin of the whale. This will be its barnacles.

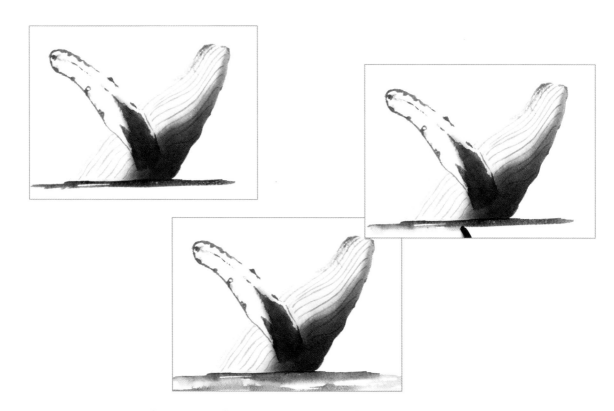

Step 8: Time to add some water for the whale to jump out of! Make a puddle on your palette with your primary blue, and add a little bit of yellow to it so that you have a combination of blue and a blue-green color. Load your brush and swipe it under the whale in a horizontal motion. I find holding my brush with the handle pointing directly towards me and moving it horizontally makes it easier to create straight lines. Swipe it once or twice, then dip your brush in water to reload it. (Don't completely clean off your brush, though some paint will wash away in the jar.) Then repeat the swiping motion under the whale, touching the first set of strokes. By having some saturated strokes and some watery strokes for the color to flow into, we create interest and make it look like light is sparkling off the water's surface.

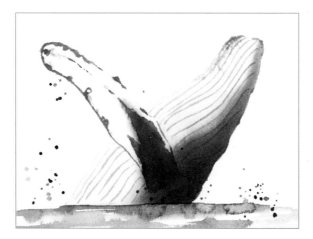

Step 9: You can do this step while the water layer is still wet. Reload your brush with the same blue/blue-green color, and hold it over areas where the whale is leaving the water, like along the back and between the fin and the water. Use your finger to tap the brush, making it splash some color down onto the paper. This helps add some movement to the piece in a quick and easy way. I like to splash some saturated drops down, then rinse my brush off a little in water and splash more diluted drops of water down to create contrast.

Step 10: Finally, create even more of a splash by loading your brush with white gouache and tapping it around the base of the whale where it's touching the water. I also like to flick some paint on by pulling my fingernail across the bristles of the brush while pointing it downwards in that area. Beware: This can get very messy both on the paper and on your finger. You can use an old toothbrush for this technique too, which can be more effective than a softer-bristled watercolor brush. You may need to do this a couple of times and experiment with how much gouache vs. how much water you need to get the white to show up. You can also use a dry brush with just a bit of blue on it to create some dry brush strokes curving from the fin towards the water, and from the top of the head towards the water, to look like water pouring down off the whale.

ocean beach

We're going to need an ocean scene for our new whale friend, aren't we? Let's paint the beach!

Techniques used: Flat washes (see page 81), wet on dry (see page 74), wet on wet (see page 73), blending (see page 78), lifting (see page 83)

Colors used: B , Y , BG , G , YO ,

B + O = B , W , Y + R + B = BL

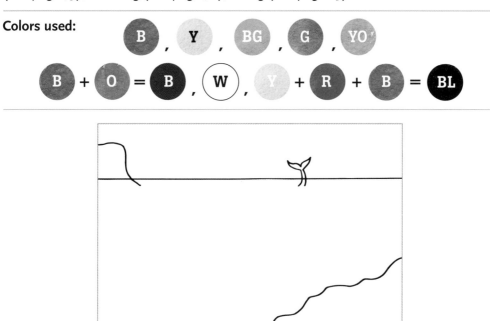

Step 1: Sketch in a couple of guidelines to make sure we keep things where they should be. Add an ocean horizon line so we know where the water starts and the sky ends. Do this by drawing a horizontal line across your page, about 1/3 of the way down. Use a ruler if you want it super straight. On the left side where the horizon line is, draw a small cliff in the distance. In the bottom right corner draw a jagged line for the shore so we can add some sand. Sketch a small whale tail near the horizon.

Step 2: Using your primary blue, paint in your sky from top to horizon line. I like to fade my sky to a lighter blue as it gets closer to the water.

Step 3: Before your sky dries, use the brush or paper towel technique from the Skies project (see page 124) to lift some clouds out. Then, paint in just a little yellow on the horizon line behind the whale tail. This will be our setting sun. Be careful not to mix the yellow with the blue, or you'll make green.

Step 4: Let's paint the ocean now. I like to use a range of blues for this: deep blue, regular primary blue, blue-green, and even some greens. Prepare these mixes on your palette using your primary blue as the base, then adding some yellow for blue-green, more yellow for green, and a tinge of orange to create your deeper blue.

Step 5: Wet the whole ocean area down, excluding the bottom right area where we'll paint the sand. The reason we want to work wet on wet is that we want to leave a diagonal line from the top right to the bottom left quite watery and pale, so it looks like the sun is reflecting on the water. Start by painting the color from left to right. Add your deep blue to the left corner near the cliff and on the opposite far right side of the ocean. Transition the color to blue-green, then primary blue as you reach the center. Leave a gap for the reflection. Continue with primary blue until you reach the shoreline, watering it down the closer you get to the sand so it looks like the water is shallow there. While it's still wet, you can add a couple of wet-on-wet patches of green on the left side, to make it look like deeper water or even some floating seaweed.

Step 6: Once your ocean is completely dry, use primary yellow and a tinge of primary red to mix up a golden yellow for the sand. Paint in the shore line in the bottom right corner, fading it out onto your ocean water. Then, with a more concentrated mix, gently paint the original shoreline.

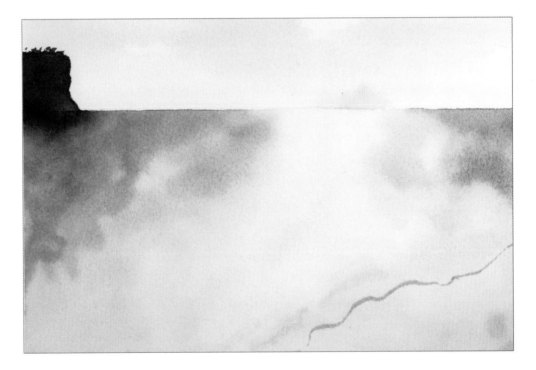

Step 7: Next we can paint the cliff. Mix up a brown using primary blue and orange (primary yellow + primary red). Paint your cliff, making the right side of it a little lighter in color, and fading it out into the ocean with a clean damp brush.

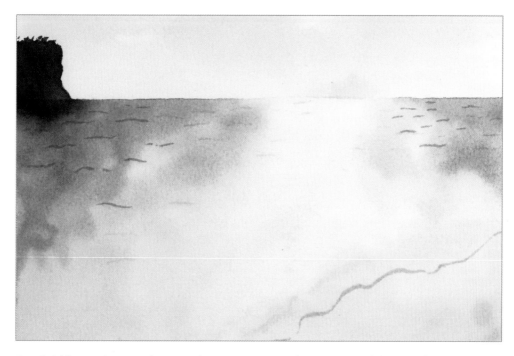

Step 8: Add some thin, wavy lines to indicate movement in the water. Spread them out farther the closer to you that you paint them.

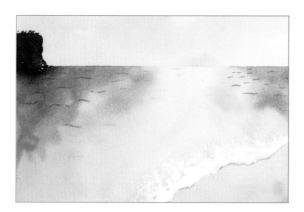 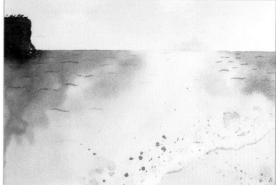

Step 9: Time to get splat-happy! First, load up your brush with white gouache and dab white all along the shore line on the water. This will create a foamy look as the waves roll in. Let it totally dry to see if you need to repeat this, as gouache can sometimes fade away if too much water is used. Then, let's take it even further! Loading up your brush again and using a scrap piece of paper to cover the rest of your painting, tap and flick more concentrated white gouache along the shoreline to create seaspray. You can also do this a tiny bit at the bottom of the cliff to make it look like waves are crashing into it. Once the shoreline has dried, use some watered-down blue and tap and dab some paint on top of the white to add dimension. Then, using your dark golden color, splat some paint on the sand to give it texture.

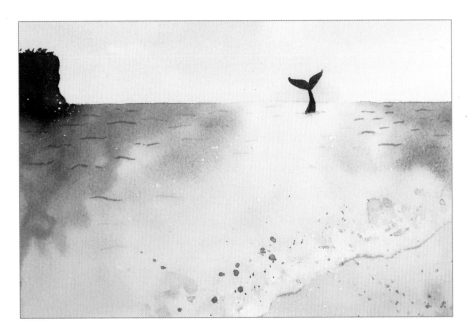

Step 10: The final step is to add a whale tail on the horizon! Paint this with a very dark blue-gray or black, using your smallest brush to get the tail silhouette really crisp. Using some more white gouache, you can also add a couple of dots along the water reflection to make it look sparkly.

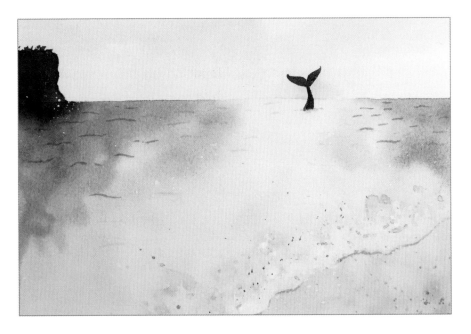

Step 11: Make any final adjustments if need be. In the above example, I lifted off some of the blue and golden splatters on the shoreline and sand.

what next?

Ready to strike out on your own as a watercolor artist? Here are some examples of variations on the projects in this book, and things you can do with the techniques you learned.

If you enjoyed the projects in this book and want to continue your watercolor journey with me, come and check out my online school, The Watercolour Academy (www.thewatercolouracademy.com).

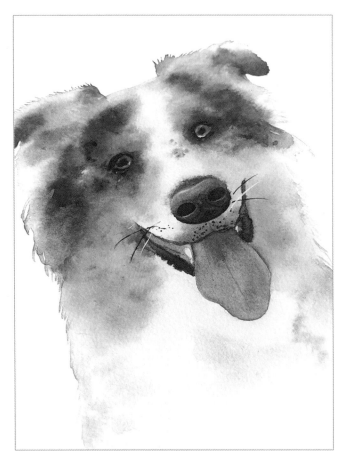

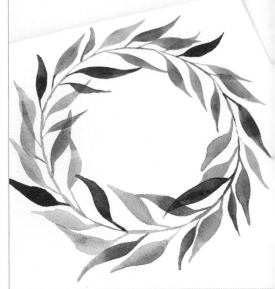

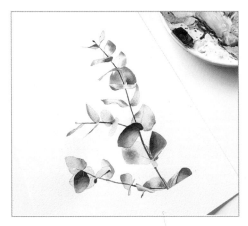

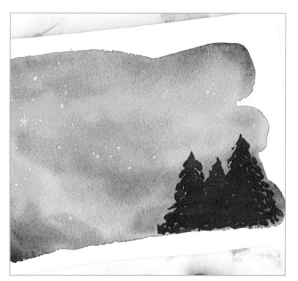

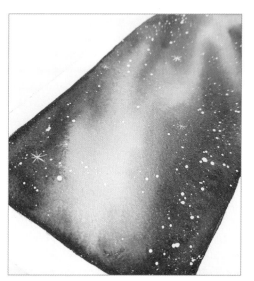

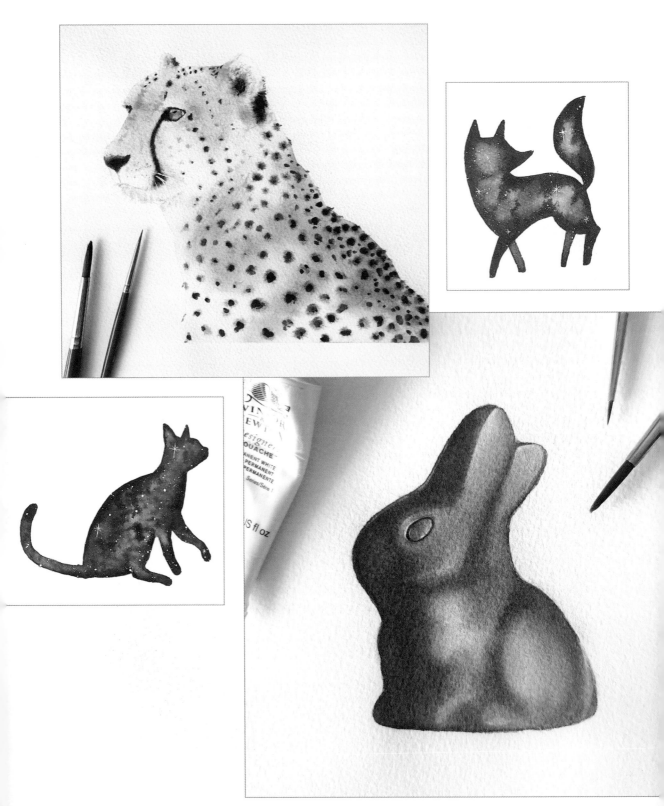

Troubleshooting

Ah, watercolor. Such a complex beast of a medium. There's an absolute myriad of things that can go wrong with watercolor, and they can happen for many different reasons. Don't get cross, get curious! Approach the mistakes with an open mind. The longer you paint, the more you'll understand why something may or may not be happening, and you'll be able to problem-solve your way out of it. Until then . . . here are some common issues and some possible ways to fix them.

My painting looks pale.

- Did you add too much water to your mix? Add more pigment to balance out the ratio of water to paint, or create a new mix. See page 66 for more on water ratios.

- Try going over it with another layer.

- Is it your paints? Are you using student or artist-grade? If student grade, you may want to consider upgrading to artist-grade. See page 20 for more on paint.

- Is it your paper? Are you using student or artist-grade? If you're not using 100% cotton paper, you may want to consider upgrading. See page 13 for more on paper.

My painting looks too dark.

- Did you use too much paint in your mix, compared to water? Try adding a little water to balance out your mix. See page 66 for more on water ratios.

- Unfortunately, it's very hard to recover a painting that's too dark. You can try lifting the top layer off with your brush or some paper towel. If you've only painted the subject, or only the background, try to make whatever is left of the painting lighter for contrast, rather than making the whole painting saturated and dark.

- This can also happen when we overwork a painting. Don't beat yourself up! Use it as a learning moment. Remind yourself to go light. You can always add, but it's very hard to erase watercolor.

My colors look muddy.

- Did you ignore my color theory advice? You can revisit it on pages 42–65.

- Is it your colors? Are you using student or artist-grade? If student grade, you may want to consider upgrading to artist-grade. See page 20 for more on paint.

- Check what pigments are in your mix. Did you mix single pigment primary colors, or did you grab a bunch of convenience colors and mix them? Convenience colors can sometimes have three pigments in a single color (Payne's gray for example), and this can turn a mix to mud because it has hidden undertones that neutralize other colors. See pages 44–47 for more mixing guidance.

- On the other hand . . . you made brown! Yay!

I keep getting harsh lines.

- Is it your paper? Are you using student or artist-grade? If you're not using 100% cotton paper, you may want to consider upgrading. Student-grade paper is my arch nemesis and gives me harsh lines so often, even if I try my hardest to avoid them. I recommend trying a different paper if you consistently experience this. See page 13 for more on paper.

- How much water is in your mix? When we paint an area, the first part to dry is the outer edge. The middle stays damp longer. If we keep adding more water and color to the middle while ignoring the edges that are drying, we will start forcing color and water out to the farthest edge of the wet area. It will run into the edge, and pigment can start to collect there, creating a harsh line. Try to keep an eye on these edges. If you can avoid taking them all the way to the edge of whatever you're painting straight away, do that. Then you can extend the edge when you're done with the middle.

- If you're careful, you can remove a dried harsh line. Do this by gently scrubbing it with a clean, damp brush. If you happen to have a stiffer brush with shorter bristles, this can be more effective than a long-bristled brush, but use what you have. Try not to push or drag the edge into a space where you don't want it, and keep cleaning your brush and drying it so that you aren't reactivating your work underneath. I like to dab the page with a paper towel too to make sure I'm leaving no moisture behind. (See page 82 for more tips.)

My blends aren't smooth.

- Is it your paper? Are you using student or artist-grade? If you're not using 100% cotton paper, you may want to consider upgrading. See page 13 for more on paper.

- Is it your paints? Are you using student or artist-grade? If student grade, you may want to consider upgrading to artist-grade. See page 20 for more on paint.

- Is it your brush? Are the bristles perhaps too rough? Or the size too small for the area you're working on?

- Don't be afraid to go over an area! If I notice my blends aren't smooth, I get a clean, damp brush (we don't want to add more color or water to the area), and I move my brush back and forth in a windshield wiper motion. This can move the water and color around and help even them out. Sometimes, watercolor blends perfectly on its own, but sometimes it needs some help!

I can see my brush strokes.

- Is it your paper? Are you using student or artist-grade? If you're not using 100% cotton paper, you may want to consider upgrading. See page 13 for more on paper.

- Is it your paints? Are you using student or artist-grade? If student grade, you may want to consider upgrading to artist-grade. See page 20 for more on paint.

- Is it your brush? Are the bristles perhaps too rough?

- Did you use enough water? See page 66 for more on water ratios.

- Did you use a little too much paint?

- Did you blend them out?

- Try working wet on wet and adding paint into water instead of directly onto your paper. See page 73 for the wet into wet technique.

My paper is drying too fast.

- Are you using student or artist-grade paper? If you're not using 100% cotton paper, you may want to consider upgrading. See page 13 for more on paper.

- What's the climate like at the moment? Sometimes it's a weather thing. If it's very dry or very hot, your paper may dry faster.

- Are you trying to paint too much at once? Make sure you're allowing yourself enough time to work on an area. You might need a bigger brush, or to paint in smaller sections.

- Are you using enough water? If you can see it soaking in straight away, add more!

My paper is buckling, shredding, or pilling.

- Is it your paper? Are you using student or artist-grade? If you're not using 100% cotton paper, you may want to consider upgrading. See page 13 for more on paper.

- It could also be the number of layers you're painting. While artist-grade paper should be able to handle many layers, a lighter weight paper has a harder limit on how much watercolor it can take.

- Are you scrubbing too hard?

My paper is warping.

- Have you tried taping it down with painter's tape?

- Could you try painting on heavier paper? If you're not using 100% cotton paper, you may want to consider upgrading. See page 13 for more on paper.

- Could you invest in a block of paper?

- Try stretching your paper. (See page 17.)

The paint beads up on my palette.

- Is your palette new? Did you prepare it? See page 36 for instructions on preparing a new plastic palette.

acknowledgements

Massive thank you to my students, customers, and internet friends from all over the world. Without your constant interest in and support of my artwork, tutorials, and paints, I wouldn't be getting to write more words in another book. The biggest part of my career as an artist to date has been helping others learn art, find joy in art, escape the world with art, and believe in themselves. Thank you for allowing me to continue to do that.

Jen, Nathan, Ally, and Shelly: my support system through the process of writing this second book, and through life in general. I appreciate you all so much, and you do more for me with your friendship than you'll ever know. Your continued encouragement, advice, and the endless laughs are what keep me going. Thank you.

I couldn't possibly not mention my doggo, Rhodie. Writing a book is generally considered an isolating experience, but instead of voluntarily and romantically locking myself away in a cabin in the woods, I've been writing the book while in mandatory social isolation. I couldn't ask for a more adorable or loving companion than my Rhodes to keep me company during this time. She hasn't learned to read (yet), but don't worry! I tell her she's the goodest girl every day. Shout out to Leo, my cat, too, even if I'm just the lady who fills his food bowl.

Again, a huge thank you to Talia Levy and the Peter Pauper Press team for letting me spill words (and paint) in another book. It is a pleasure working with you, and I'm forever grateful.

about the author

Emma Witte, also known as Black Chalk Collective (@blackchalkco), is a full-time artist from Australia. Emma loved art as a kid, but didn't dabble in it again until late 2015 when she was looking for a creative outlet from the combined pressures of the corporate world and university.

Emma's art obsession started with brush lettering after spontaneously attending a workshop. She would go on to teach her own workshops online and around the world, run a calligraphy-focused print and digital magazine for two and a half years, and have her first book published: Brush Lettering from A to Z.

Along the way, Emma began experimenting with watercolor and quickly fell in love with the challenge and excitement of its unpredictable and uncontrollable nature. In 2018, she released a color theory class online, which has since seen thousands of students take part and learn how to turn three colors into 144. This quickly expanded into an online school today known as The Watercolour Academy. Later that year, Emma also started making her own paint so she could better help her students, and now she offers a range of handmade colors through The Watercolour Factory.

Emma is a firm believer that anyone and everyone can create beautiful art with just a little time, patience, and perseverance. She is also passionate about helping other creatives turn their hobbies into something more and co-hosts the Hobby to Business podcast with Shelly Kim.

Emma resides in Melbourne with her two furry children, Rhodie the dog and Leo the cat, and to no real surprise: her favorite things to paint are animals!

Website: thewatercolouracademy.com
Instagram: instagram.com/blackchalkco
YouTube: youtube.com/blackchalkco